# 50 GEMS
# Stirling District

JACK GILLON

AMBERLEY

First published 2022

Amberley Publishing
The Hill, Stroud
Gloucestershire, GL5 4EP

www.amberley-books.com

Copyright © Jack Gillon, 2022

Map contains Ordnance Survey data © Crown copyright and database right [2022]

The right of Jack Gillon to be identified as the Author
of this work has been asserted in accordance with the
Copyrights, Designs and Patents Act 1988.

British Library Cataloguing in Publication Data.
A catalogue record for this book is available from the British Library.

ISBN 978 1 3981 1152 3 (paperback)
ISBN 978 1 3981 1153 0 (ebook)

Typesetting by SJmagic DESIGN SERVICES, India.
Printed in Great Britain.

# Contents

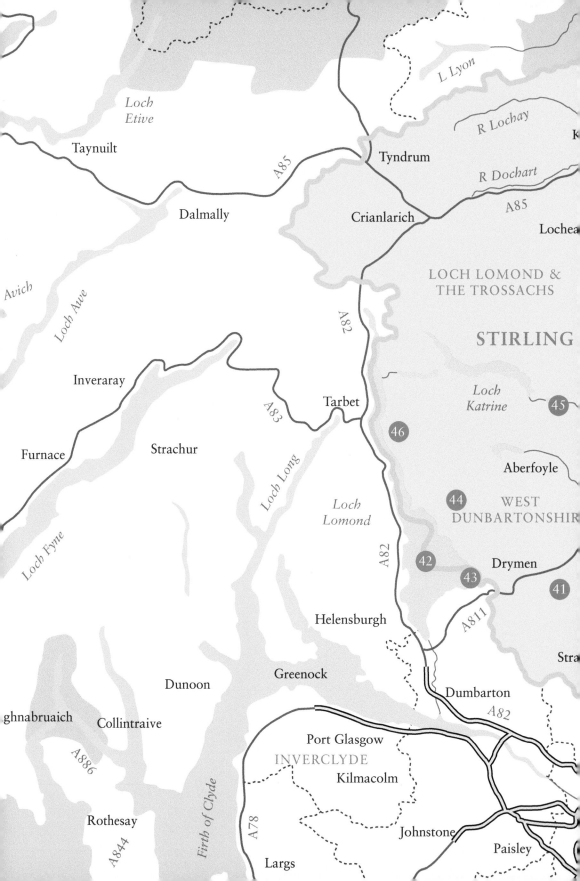

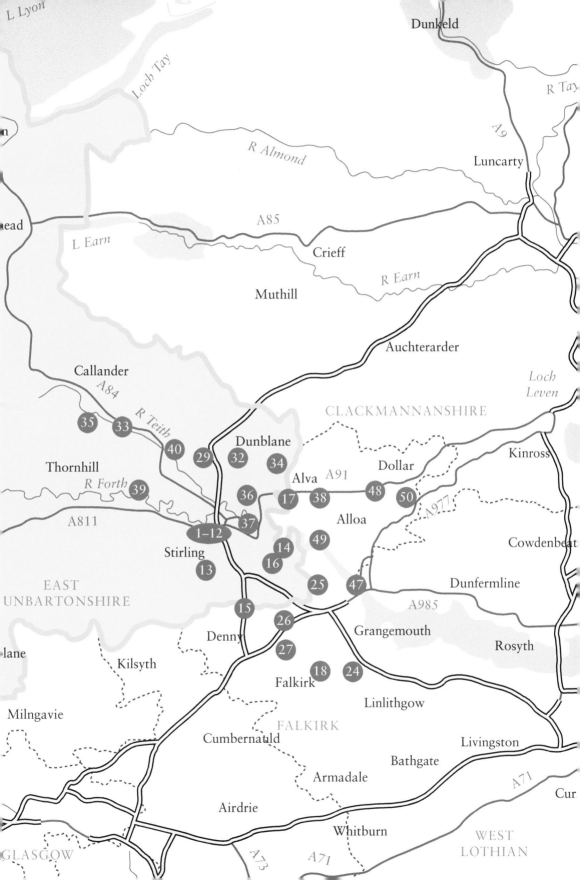

# Introduction

The county of Stirling, from its situation upon the isthmus between the firths of Clyde and Forth, together with its direct passage from the northern to the southern parts of the island, has been the scene of many memorable transactions. There are indeed few shires in Scotland that can show the site of so many ancient monuments; nor does it yield to any in point of those modern improvements which have led to the advancement of commerce and manufactures.

William Nimmo
*The History of Stirlingshire* (1880)

This book takes the historic boundary of Stirlingshire as its main reference. However, it also includes places of interest that are close to its boundaries, including a venture into the historic county of Clackmannanshire.

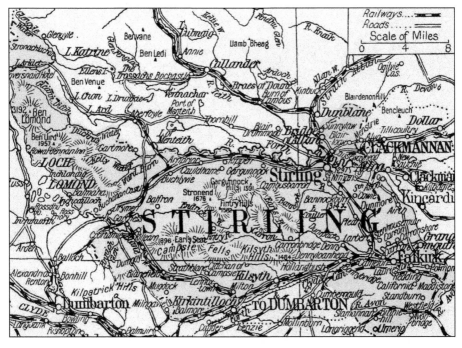

Historic boundary of Stirlingshire.

Stirlingshire is central to Scotland and its history. Spanning the boundary between the Highlands and Lowlands, and standing at the heart of Scotland, the town of Stirling was 'the key of the Highlands'. The town developed at the lowest bridging point over the Forth, which was a vitally strategic crossroads, and the location of the rugged volcanic crag of the Castle Rock. The town grew on the steep tail that runs down from the castle's rocky crag and early settlement prospered under the protection of the castle. It was one of the four principal royal burghs of Scotland; the most ancient charter of the burgh was granted by Alexander I in 1120. During the thirteenth and fourteenth centuries, the castle and town were razed during the Wars of Independence between England and Scotland. In the fifteenth and sixteenth centuries, the Stuart kings made Stirling their favoured residence and the arrival of the royal court did much to foster the status of the town, with the nobility building elaborate townhouses (lodgings) for convenient attendance at court. Granted city status in 2002 as part of the Queen's Jubilee celebrations, it is a thriving city with a proud and distinctive identity, which retains much of its ancient character and a wealth of fine heritage buildings.

Falkirk was the industrial heartland of the area. Its strategic location, midway between Edinburgh and Glasgow, at the crossroads of lowland Scotland, was the main influence on the town's development and has contributed to its key role in Scotland's history. The Romans were the first to make a significant mark on the district, William Wallace and Bonnie Prince Charlie fought the English nearby, cattle were driven from all over Scotland to the great trysts in the area, and local foundries fuelled the Industrial Revolution.

The greater part of the western section of the area consists of small villages and towns, open spaces and extensive swathes of great natural beauty, which are most clearly represented by the outstanding scenery of the Trossachs and Loch Lomond.

The book explores the places that make this part of Scotland special, including natural features, towns and villages, buildings, and places of historical interest. Unavoidably, there will be readers who disagree with the choices of what represents a gem. The selection includes some of the major landmarks in the area and several possibly lesser-known and more uncommon places.

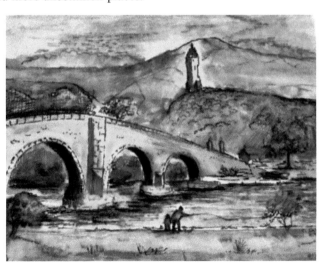

Stirling Bridge and Wallace Monument by Norman Gillon.

# 1. Stirling Castle

Stirling, than which there are few towns more distinguished for historical incident, and certainly none more remarkable for beauty of situation, is at least as ancient as any other of our present towns, and unquestionably much older than the most of them. Like the metropolis of its kingdom it is built on an eminence that rises gradually from the east, and is bounded on the west by its veteran fortress, raised on the summit of a high and precipitous rock, and affording from its commanding situation, views of surrounding scenery which for richness and variety are perhaps unsurpassed in any other portion of the world.

*A New Description of the Town and Castle of Stirling* (1935)

The most interesting and important edifice in Stirling is the Castle crowning the precipitous extremity of the ridge on which the town is built and forming the most conspicuous object to the surrounding country.

*The Merchants' Guide to Stirling* (1897)

Set dramatically on its high crag, Stirling Castle dominates the landscape for miles around. Although there is no clear evidence, it is likely that the naturally defensive site of the castle was a stronghold from prehistoric times. The earliest reference to the castle is in the early twelfth century, when Alexander I endowed a chapel within it. The castle changed hands repeatedly in the wars between Scotland and England.

Stirling Castle.

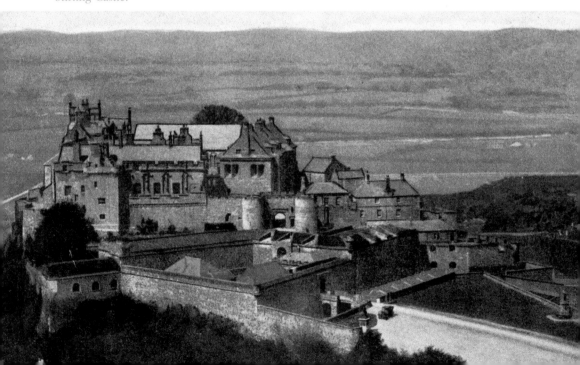

Most of today's castle buildings date from the time in the late fifteenth to sixteenth centuries when it was a fortress, royal palace and a favourite residence of the Stuart kings. After the Union of the Crowns in 1603, the Stuarts effectively abandoned the castle as a residence. The castle was in use as a military base from the late seventeenth century and additional defences were built in 1708, due to the unrest caused by the Jacobite threat.

The castle is well defended on three sides by steeply sloping rock faces. The approach from the south was more of a soft target and was the most fortified. The present forework dates from around 1506 and was built under the reign of King James IV. It originally consisted of six towers with conical roofs, which, along with the guardhouse, were twice as high as at present.

The national importance and tourism potential of Stirling Castle was recognised in the 1960s and a programme of restoration works undertaken. The castle is now one of the most visited tourist sites in Scotland.

# 2. The Royal Palace, Stirling Castle

The Palace at Stirling Castle is a quadrangular building, having three ornamental sides presented to the view of the spectator. On each of the ornamented sides there are six recesses, in each of which a pillar rises close to the wall, having a statue on the top. Most of those on the eastern side are mythological figures. On the northern side, the figures are more of this world's kind of beings; the first from the east corner is unquestionably a statue of the royal founder. Above and below the figure there runs a wreathed scroll, which is considered unique. The visitor may derive a very good hour's amusement from the inspection of these curious relics, some of which are valuable as commemorating costumes of former times.

John Forbes
*The Tourist's Companion Through Stirling* (1848)

The Royal Palace at Stirling Castle was built during the latter part of the reign of James V as appropriately prestigious accommodation for the king and his queen, Mary de Guise. Work started in the 1530s and it was mainly complete at the time of James' death in December 1542. The interior originally consisted of an almost symmetrical arrangement of a matched group of rooms of state – a public outer hall where nobles and courtiers met the monarch; an inner hall, for more exclusive audiences; and an inner bedchamber for the most elite circle of advisers. Daniel Defoe described them as 'the noblest I ever saw in Europe, both in Height, Length and Breadth'. The rooms were grouped around a paved courtyard known as the Lion's Den – from the heraldic lion of Scotland or possibly from the fact that it housed a real lion. The palace was the childhood home of the young Mary, Queen of Scots.

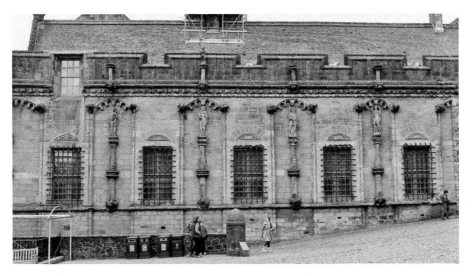

The Royal Palace: Stirling Castle from the inner courtyard.

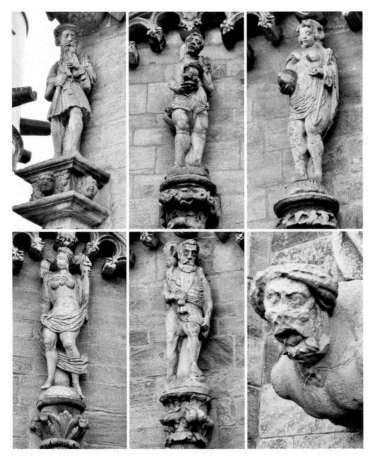

Statues at the
Royal Palace,
Stirling Castle.

The palace continued in use as an important royal residence until the Union of the Crowns in 1603, when the court moved to London and the building lost its main purpose. It was gradually converted for military accommodation in the eighteenth century. After the departure of the army in 1964, the building served as a function room and café. In June 2011, the building opened to the public after a £12 million project to recreate its original splendour. This included replicas of a series of the beautifully carved oak portrait roundels, known as the 'Stirling Heads', which were originally installed on the ceiling of the King's Presence Chamber. The original heads had been taken down in 1777, as they had become insecure.

The exterior of the palace is festooned with around 200 bold carvings, which represent a unique collection of Scottish Renaissance sculpture. A Devil, grotesque monsters and a line of armed soldiers face the outside. Classical deities and musicians decorate the inner courtyard. James V (top left in the collage) is depicted in a more natural form with a bushy beard and wearing the Highland dress of the time. They would originally have been painted and gilded, and were designed to proclaim the king's importance. R. W. Billings (1813–74), the Victorian architectural historian, described them as 'the fruits of an imagination luxuriant but revolting'.

# 3. The Great Hall, Stirling Castle

The Great Hall was completed in 1503, in the reign of James IV. It was intended as a magnificent venue for royal occasions and is the largest and finest medieval hall in Scotland, requiring five fireplaces to heat it. The hall was used for the

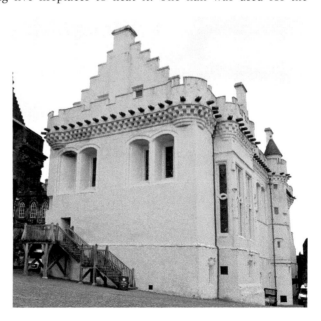

The Great Hall, Stirling Castle.

baptisms of James VI in 1566 and Prince Henry in 1594. The banquet following the christening of Prince Henry was a lavish affair with a huge boat floating in an artificial sea, dispensing sweetmeats and equipped with working cannons for a salute to the young prince. The hall was very occasionally used for sittings of Parliament.

After the Union of the Crowns in 1603, the hall was no longer required for its original ceremonial uses and it was radically adapted by the military. Since the army moved out in the mid-1960s, the hall has been the subject of a major restoration scheme, which has returned it to close to its original condition. This included the renewal of the spectacular hammer-beam roof and the controversial golden yellow limewash. The restored Great Hall was opened by Queen Elizabeth II on 30 November 1999.

# 4. The King's Knot

The King's Knot, within the King's Park, is a significant built landscape feature that is historically closely associated with the castle. The knot consists of a concentric, stepped, octagonal mound covered with grass and formed part of a magnificent seventeenth-century formal garden. It was originally the centrepiece of a surrounding rectangular parterre garden, which would have been planted with box trees and ornamental hedges. The King's Knot is known locally as the 'Cup and Saucer'. The Queen's Knot is a smaller, less distinct mound within the gardens.

> The King's Gardens lie immediately to the south-west of the Castle-hill, and to the south of the Castle. Their present condition is that of a marshy piece of pasture-ground. This interesting monument of the taste of our national sovereigns is completely desolated, so far as shrubs and flowers are concerned. The utmost exertion of the memory of the present generation, can only recollect an old cherry-tree, which stood at the corner of one of the parterres, and which was burnt down by the wadding of a shot, which some thoughtless sportsman fired into its decayed trunk, as he happened to pass it on his way home from the fields. It is yet possible, however, to trace the peculiar form into which the ground had been thrown by its royal proprietors. In the centre, a series of concentric mounds, of a polygonal, but perfectly regular shape, and rising above one another towards the middle, are yet most distinctly visible. An octagonal mound in the centre, is called the King's Knot, and is said, by tradition, to have been the scene of some forgotten play or recreation, which the King used to enjoy on that spot with his court. In an earlier age, this strange object seems to have been called the Round Table; and, in all probability, it was the scene of the out-of-door's game of that name, founded upon the history of King Arthur. To give further countenance to this supposition, we have ascertained the fact that James IV,

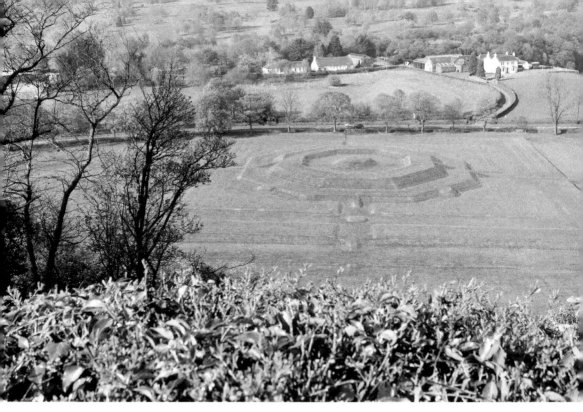

The King's Knot.

with whom Stirling was a favourite and frequent residence, was excessively fond of the game of the Round Table, which probably appealed, in a peculiar manner, to his courtly and chivalric imagination.

<div style="text-align: right">

Robert Chambers
*Picture of Stirling* (1830)

</div>

The gardens were built on the site of the Round Table, which is referred to in the 1530 poem 'Testament and Complaynt of our Soverane Lordis Papyngo' by Sir David Lindsay: 'Adieu, fair Snawdoun, with thy towris hie, Thy Chapill – Royal, Park, and Tabill Round.' Stirling had strong associations with King Arthur, and it was long claimed that Stirling Castle was the Snowdon of Arthurian legend. The site was used for medieval jousting tournaments 'in the spirit of the Knights of the Round Table, which the courtly personages of former times are known to have been so fond'.

# 5. The Valley Cemetery

Immediately beneath the castle esplanade to the south lies the town cemetery. The scene, while full of impressive loveliness, is also very

deceptive. From the natural beauty of the situation, and the exquisite skill with which statuary, shrubbery, and rockeries are arranged throughout the burial garden, it is hard to be convinced that what is seen is for the most part artificial.

William Nimmo
*The History of Stirlingshire* (1880)

We know of no sweeter cemetery than that of Stirling.

William Wordsworth

The Valley Cemetery was laid out in 1857–58 by Peddie and Kinnear as an extension to the kirkyard of the Church of the Holy Rude. It was previously an important open space between the castle and the town where jousting and public events, such as horse markets, were held. The rocky outcrop that overlooks the cemetery is known as the Ladies' Rock and formed an elevated vantage point for the ladies of the court to view the royal tournaments – it continues to provide panoramic views across the Trossachs and Ben Lomond.

The creation of the Valley Cemetery was due to Revd Charles Rogers. Rogers was chaplain at the castle and a town councillor. He was said to have had a degree of statue mania – he was responsible for the Wee Wallace on the Atheneum, Bruce on the esplanade, the Martyrs' Monument and the statues of the heroes of the Scottish Presbyterian Reformation (John Knox, Andrew Melville, Alexander Henderson, James Renwick, James Guthrie and Ebenezer Erskine) in the Valley Cemetery. The cemetery was largely funded by William Drummond.

The Virgin Martyrs' Monument in the Valley Cemetery depicts an angel watching over two young girls, with the older of the two reading the Bible to the other. It commemorates two young Wigtownshire girls, Margaret and Agnes Wilson, who were sentenced to death by drowning in 1685. The girls were Covenanters and refused to swear an oath of allegiance to Charles II, which amounted to them committing high treason. Agnes, who was in her early teens, had her sentence commuted. However, Margaret, who was eighteen, along with an elderly neighbour, Margaret McLaughlin, were tied to stakes on 11 May 1685 in the Solway Firth and left to drown in the incoming tide. The monument was erected in 1859 and the cupola was added in 1867. The sculptor was Alexander Handyside Ritchie (1804–70) and the cupola was by John Rochhead, the architect of the National Wallace Monument.

On the north side of the cemetery stands a pyramidal emblem in stone of the permanence of Scripture. The building, which was erected by one of Stirling's most generous sons – Mr. William Drummond – is not less curious-looking than imposing; and, in addition to a formidable array of hieroglyphic signs, displays a variety of biblical quotations. Down in the valley are many interesting, though less striking objects; a pretty pond, a tasteful water-fountain, and several fine statues of Scotch martyrs.

William Nimmo
*The History of Stirlingshire* (1880)

As the name suggests, William Drummond (1793–1868), Stirling's prolific benefactor, was responsible for the Pleasure Ground, which is the setting for the Star Pyramid. Drummond was a prominent Stirling businessman who is described as a 'seedsman, evangelist and an ardent Presbyterian'. He was the brother of Peter Drummond (1799–1877), the founder of Stirling's Drummond Tract Enterprise. The Pleasure Ground was laid out in 1863 as a setting for the Star Pyramid, the largest pyramid structure in Scotland. The pyramid is dedicated to the cause of the Presbyterian Church in Scotland – it also publicised his brother's Drummond Tract Enterprise. The pyramid form was popular at the time as a symbol of stability and endurance. William Drummond's massive, polished, grey granite sarcophagus, inscribed 'Born 14 February 1793 Died 25th November 1888', stands next to the pyramid.

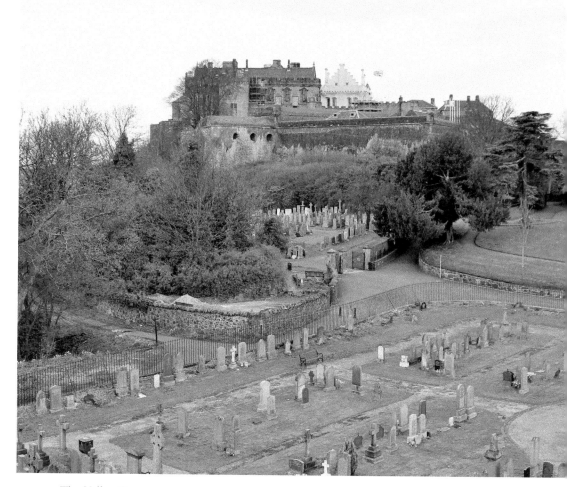

The Valley Cemetery.

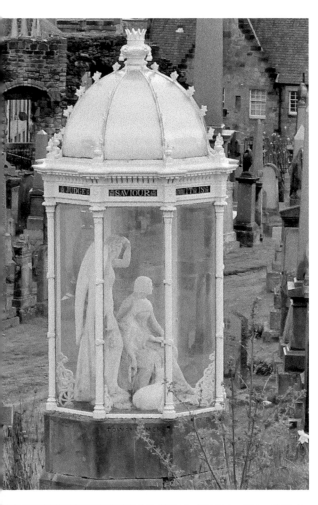

*Left*: The Virgin Martyrs' Monument.

*Below*: The Star Pyramid.

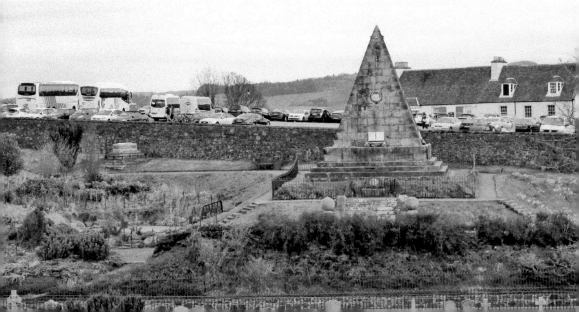

# 6. The Church of the Holy Rude, Castle Wynd

The Church of the Holy Rude is the original parish church of Stirling and one of Scotland's most important medieval buildings. A church was first established on the site in 1129 during the reign of David I (1124–53). Between 1371 and 1390, King Robert II dedicated an altar to the Holy Rude (Holy Cross) within the church and it became known as the Holy Rude. The original church was destroyed, along with much of Stirling, in a devastating fire in 1405. The new church with its distinctive square belfry tower was rebuilt from 1414.

In the medieval period the Scottish burghs generally contained only one parish church, which was central to the life of the community. It was accordingly of significant scale and splendour, with chapels and adornments added by the trade guilds and private individuals.

The church is closely associated with the monarchy. It was the venue for the coronation of Mary, Queen of Scots on 9 September 1543 and the hastily arranged coronation of her son, the infant James VI, on 29 July 1567, after his mother was forced to abdicate. It is the only church in the United Kingdom, apart from Westminster Abbey, to have hosted a coronation and that is still used for public worship.

The church was restored in the late 1930s, when the partition that had divided the building into two places of worship was removed.

The walls of the church show signs of musket shot and cannon fire from battles around the castle.

The Church of the Holy Rude.

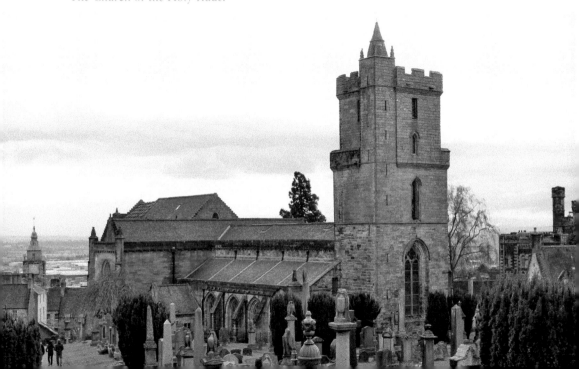

# 7. Argyll's Lodging, Castle Wynd

On the other side of the Wynd is a building of much architectural merit, an examination of which will well repay the time spent on it. It dates from 1632 and is certainly the finest specimen of the architecture of that period to be found in the district. It was built by Sir William Alexander of Menstrie, afterwards Earl of Stirling, poet, courtier, and statesman, and the crest and motto over the doorway are his. After his death, in 1640, the house became the property of the Earl of Argyll. Hence the name of Argyll's Lodging, by which it has ever since been known. The property was held by the Argylls till well on in the eighteenth century, and then passed through several hands, till, just about a hundred years ago, it was purchased by the Government and converted into a military hospital. Argyll's Lodging, besides affording house room to its proprietors when required, has had its royal residents. It was occupied by Charles II, when he was here in 1650 endeavouring to regain the throne his father had lost. The last royal personage who spent a night under its roof was the Duke of Cumberland, in 1746, who rested here, in his pursuit of Prince Charlie, till the bridge was sufficiently repaired to allow him and his army to resume their northward march. He also was presented with the freedom of the burgh – the tickets for him and the Prince of Hesse being delivered in silver

*Below and opposite*: Argyll's Lodging.

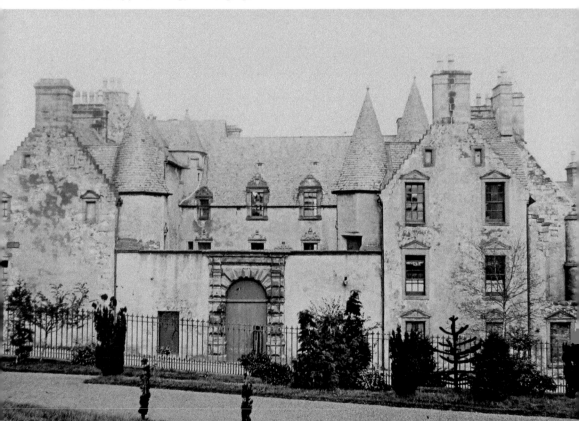

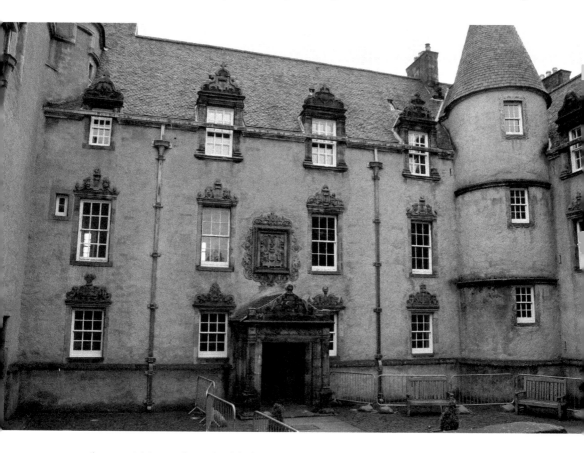

boxes richly made and gilded – perhaps to cover the facility with which the Magistrates had admitted the rebel prince into the town.

*A Guide to Stirling in 1911*

Argyll's Lodging is the most important and complete surviving seventeenth-century town house in Scotland. It sits behind a screen wall with a rusticated entrance gateway on Castle Wynd, on the final approach to the castle.

The lodging was developed from a small sixteenth-century house in several phases and by a number of owners. In 1629, Sir William Alexander was the new owner and had the house enlarged and remodelled. Sir William was involved in the settlement of Nova Scotia and an armorial tablet on the wall above the main entrance displays Alexander's coat of arms with the shield supported by a Native American. Scrolls show his family motto, '*avt spero avt sperno*', and the motto of Nova Scotia, '*per mare per terras*'.

Archibald Campbell then bought the house and made significant enlargements and alterations – the courtyard was enclosed behind a screen wall and an elaborate entrance gate installed. In 1764, the 4th Duke of Argyll sold the house and it remained in domestic use until 1800 when it was purchased by the army for use as a military hospital. It became a youth hostel in 1964. In 1996, it was restored to its former historic splendour and opened as a museum.

# 8. Stirling Smith Art Gallery and Museum

The inhabitants of the ancient burgh of Stirling held holiday yesterday in honour of the opening of the Smith Institute, an event which had been anticipated for months past with a growing degree of interest. This valuable institution, which combines in itself a fine art gallery, a museum, and a public library, has been erected and endowed from funds amounting to the sum of £22,000, bequeathed for the purpose by the late Mr Thomas Stewart Smith of, Fitzroy Square, London, and formerly of Glassingall, in the county of Perth. An artist by profession, Mr Smith's chief design in making the bequest was to cultivate among the people a love of the fine arts; and the later years of his life were devoted to gathering together the nucleus of the collection which now adorns the walls of the Institute. The building, which is in the Italian style of architecture, is from designs prepared by David Lessels, architect, Edinburgh, and, in addition to the merit of a pleasing exterior, possesses the important requisite of being admirably adapted for the uses to which it is applied. The inaugural ceremony took place in the picture gallery of the Institute. The weather, unfortunately, proved most unfavourable. Rain fell heavily during the whole forenoon and it was impossible to move about the streets with any degree of comfort and pleasure; but not withstanding there was a large attendance of the townspeople and of the residents of the surrounding district.

*The Glasgow Herald* (12 August 1874)

The Smith Institute was formally opened by Sir William Stirling Maxwell MP on 11 August 1874. The day was declared an official holiday in Stirling, and it was an event for celebration in the town, with shops closing early to allow people to attend the opening.

The neat little neoclassical building with its Roman Doric portico was funded by a bequest of £22,000 from Thomas Stuart Smith of Glassingall, Perthshire. Smith, who was a talented artist and an affluent art collector, donated his own paintings and art collection to the institute.

The institute originally contained a picture gallery, museum and a reading room. It is now known as the Stirling Smith Art Gallery and Museum, and is a significant cultural and community asset for Stirling.

The gallery houses an excellent collection of Scottish artworks and some unique artefacts, including the world's oldest football and the Stirling Jug, which dates from 1457 and was used as the standard for Scottish measures.

Under the keeping of the governor of the old prison are a few ancient curiosities, particularly the Pint Measure, but better known by the name of the Stirling Jug, appointed to be the legal standard for dry and liquid measure, by an act of the Scottish Parliament in 1437. It is made of a sort of coarse brass, and weighs 14 lb. 12 oz. 2 dr. Scottish Troy. Its mean depth is 6 inches; its diameter at

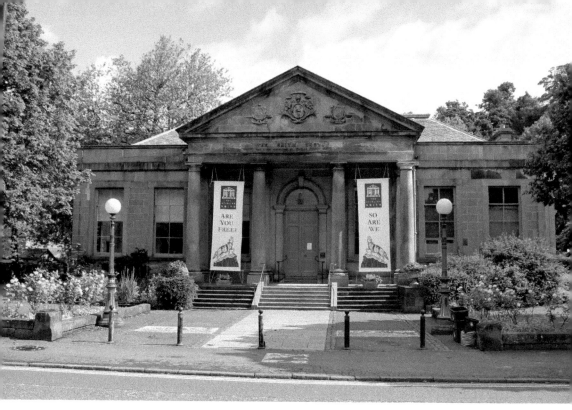

the top 4.17 inches, and at the bottom 5.25 inches. It contains 103.404 cubic inches, or 3 lb. 7 oz. Scots Troy weight, of clear river water, being equal to 3 lb. 11 oz. 13.44 dr. Avoirdupois. The handle of the Jug is fastened to it with two brass nails, and the whole has an appearance of antiquity and rudeness quite characteristic of its very early age.

*A New Description of the Town and Castle of Stirling* (1835)

# 9. Cowane's Hospital – The Guildhall, St John's Street

John Cowane (1570–1633) was one of Stirling's wealthiest and most influential merchants – shipowner, wine merchant, banker, town councillor, Member of Parliament for Stirling and dean of the Merchant Guild. His house on St Mary's Wynd, which dates from 1603, was one of the largest in the town. Cowane never married and lived at the house with his sister, Agnes, although in 1611 he was fined for fathering a child out of wedlock. The building was purchased by the Cowane's Hospital in 1924 and is now preserved as a picturesque ruin. On his death in 1633, Cowane left large sums of money to numerous charitable causes in Stirling.

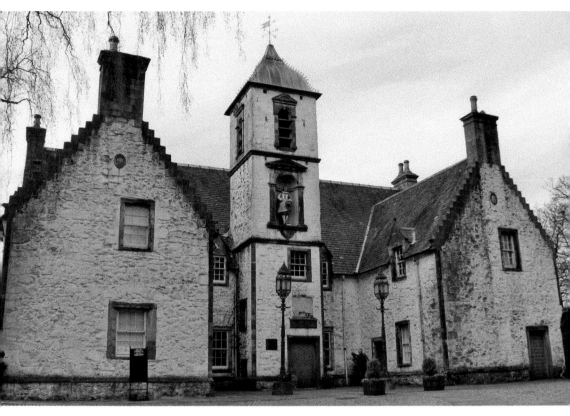

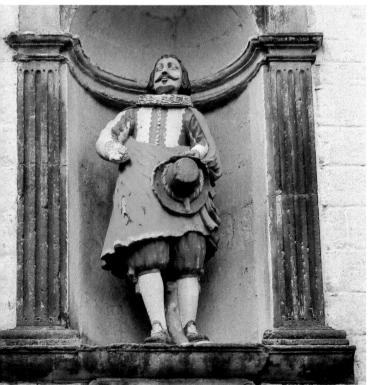

*Above*: Cowane's Hospital.

*Left*: Auld Staneybreeks.

The distinctive Cowane's Hospital was built between 1637 and 1648 as an almshouse for destitute members of the Merchant Guild. It was funded by a bequest in the will of John Cowane. The building was reconstructed as a Guildhall in 1852.

In the 1660s, the grounds were laid out with ornamental gardens and in 1712 Thomas Harlaw, gardener to the Earl of Mar, laid out a bowling green, which is one of the oldest in Scotland. The cannons in the grounds were captured at Sebastapol during the Crimean War.

At the time of writing, the building is closed due to deterioration of the building fabric. However, Heritage Lottery Funding has been allocated for repairs and conversion into a visitor attraction.

Over the entrance to the Guildhall is a niche with a statue of John Cowane and the inscriptions: 'This Hospital was erected and largely provyded by John Cowane, Deane of Gild, for the Entertainment of Decayed Gild Breither. John Cowane, 1639.' and 'I was hungrie and ye gave me meate, I was thirstie and ye gave me drinke, I was a stranger and ye tooke me in, naked and ye clothed me, I was sicke and ye visited me. Matt. xxv. 35.'

The statue of John Cowane is known as Auld Staneybreeks ('old stone trousers'). There is a local legend that every Hogmanay Auld Staneybreeks gets down for a dance in the courtyard.

# 10. Mar's Wark

Part of the elaborate front façade of Mar's Wark, which dominates the top of Broad Street is all that remains of the once splendid town mansion of John Erskine, Earl of Mar. Mar's Wark or Lodging was commissioned in around 1569 by the influential Erskine, hereditary keeper of Stirling Castle and one time regent of Scotland. The façade features an abundance of sculptures with the royal armorial bearings of Scotland over the entrance and the Erskine family heraldic panels on the two flanking towers. A number of humorous rhyming inscriptions are also included:

> I pray all luikaris on this luging, With gentile E to gif thair juging.
> I pray all lookers on this lodging, with gentle eye to give their judging.

> The moir I stand on oppin hitht. My faultis moir subject ar to sitht.
> The more I stand on open height, My faults more subject are to sight.
> (I am conspicuous, so my mistakes are more apparent)

The proximity to the castle made Castle Wynd one of the most significant parts of the town and several of Stirling's most noteworthy historic buildings were built in the area – Mar's Wark, the Argyll Lodging and the Church of the Holy Rude.

Mar's Wark was converted into barracks after the 1715 Jacobite rebellion and was badly damaged during the 1746 siege of the castle. The building ended its life rather ignominiously as the town workhouse.

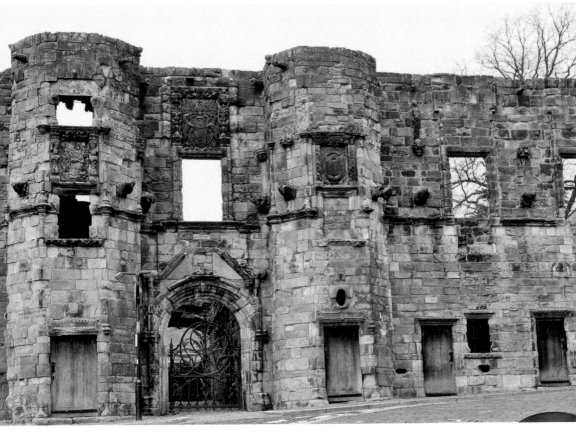

Mar's Wark.

Much of the stone used in the construction of Mar's Wark was salvaged from the ruinous Cambuskenneth Abbey and the lodging itself was subsequently used as a quarry for other building projects. It is said that the only reason that it survived in any form was because it sheltered the marketplace from the winds whistling down Broad Street.

# 11. Mote Hill, Stirling

Mote Hill is the northern section of the Gowanhill part of the royal park around Stirling Castle. The climb up the hill is rewarded by an outstanding view to the Abbey Craig and the Wallace Monument with the Ochils in the background. It is 'a picture of natural beauty which is difficult to surpass'.

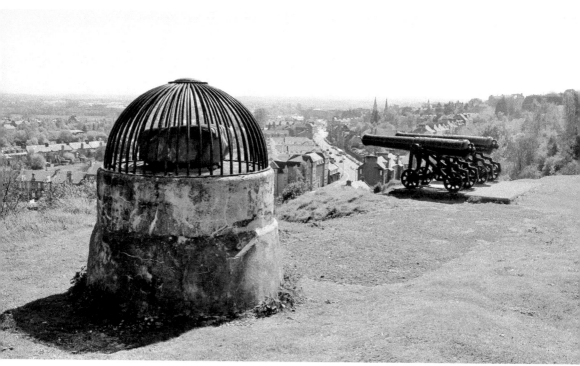

*Above*: Mote Hill

*Below*: View from Mote Hill.

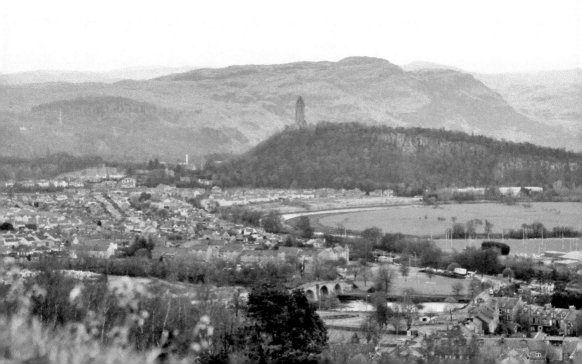

Mote Hill was known locally as 'Hurly-haaky' (or 'Hurly-hawky'), derived from a local pastime that involved sliding down the hill on a cow's head skeleton. The two cannons were purchased by the town council from the army at Stirling Castle and moved to the hill for decorative purposes. The main feature on the hill is the beheading stone.

The beheading stone on Mote Hill was used for capital punishments in the fifteenth century. It is circular with several holes to hold the wooden beheading block. Heiding Hill, the alternative name for Mote Hill, alludes to the grizzly use of the site. The stone was used in the execution of some notable people including the Duke of Albany, his second son, Alexander, and his father-in-law, the Earl of Lennox, in 1424. Sir Robert Graham and some of his associates in the assassination of King James I were also executed in 1437 on Heiding Hill. The stone is now on a concrete base and is protected by an iron grille, but the axe marks from executions are still visible.

# 12. Stirling Bridge

The old bridge is by far the most noted structure of the kind in Scotland. It is the first erection of the sort which occurs on the Forth; and was, till lately, almost the only access for wheeled carriages from the south into the north of Scotland. Its age is unknown. The first mention made of it is in 1571, when Archbishop Hamilton was hanged on it by the king's faction, under the regent Lennox. General Blackeney, the governor of the castle, caused the south arch to be destroyed in 1745, in order to intercept the Highlanders.

John Forbes
*The Tourist's Companion Through Stirling* (1848)

The Old Bridge, an ancient relic, much admired for its spacious and lofty arches; venerable from its antiquity; beautiful from its situation; and interesting in the highest degree on account of its celebrity in Scottish history.

*A New Description of the Town and Castle of Stirling* (1835)

Stirling owes much of its early prominence and prosperity to the beautiful and picturesque Stirling Old Bridge, which for centuries was the only roadway over the Forth and the most strategically important river crossing in Scotland. The construction of the bridge is ascribed to Robert Duke of Albany, Earl of Fife and Menteith. The bridge, protected by the castle, is the main reasons for Stirling's existence. A bridge, probably in timber, existed at least as early as the thirteenth century.

The roadway of the bridge is supported on four semicircular arches – none of which has the same width of span. The bridge previously had massive towers with arched gateways at each end. The southern arch of the bridge was cut in 1745, during the Jacobite rebellion, to prevent the Highlanders from crossing into Stirling. The bridge was closed to vehicles in 1834.

The bridge is downstream from the earlier wooden bridge that spanned the Forth and was the site of the Battle of Stirling Bridge. The old wooden bridge at Stirling, which was central to the Battle of Stirling Bridge on 11 September 1297, was located around 180 yards upstream from Stirling Old Bridge. The battle was a famous victory for Scotland's national hero, William Wallace, during the First War of Scottish Independence.

Stirling New Bridge is just downstream from the Old Bridge. It was opened in 1832 and was designed by Robert Stevenson (1772–1850), one of Scotland's most eminent civil engineers, renowned designer of lighthouses and the grandfather of Robert Louis Stevenson. An alternative design by Thomas Telford was rejected.

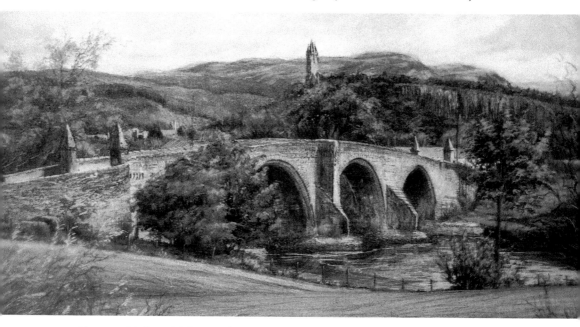

*Above and below*: Stirling Bridge.

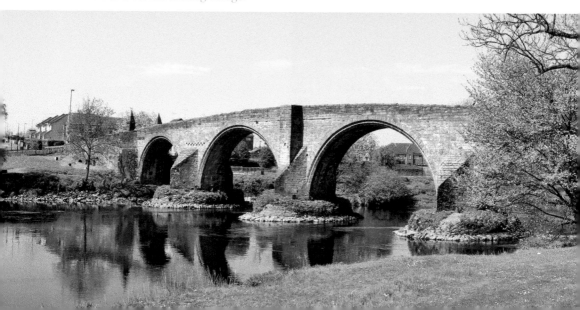

# 13. St Ninian's Tower, Kirk Wynd

St Ninian's is an ancient village, approximately one mile south of the centre of Stirling. It developed around the kirk, which is first recorded in the mid-twelfth century.

The early church, which had fallen into disrepair, was extensively altered and rebuilt in the early eighteenth century. However, it was mainly destroyed in 1746, when it was being used by the Jacobite army as a gunpowder magazine. Only the tower, which dates from 1734, and part of the earlier chancel survived the blast. A new parish church was built in 1751 to the east.

St Ninian's prospered in the eighteenth and nineteenth centuries based on local weaving, mining and nail making. After the Second World War, large-scale demolition and road building resulted in the loss of many historic buildings in the village.

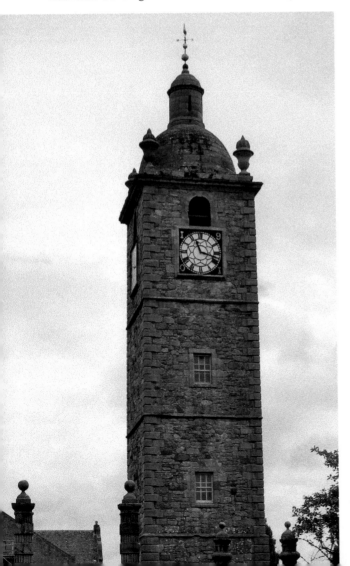

St Ninian's Tower.

# 14. The National Wallace Monument, Abbey Craig

It took a long time for a fitting memorial to be built to Wallace, but when this great landmark was built its grandeur more than compensated for the delay. From the 1820s onwards, proposals had been made for different sites in both Edinburgh and Glasgow for a monument to Wallace. In 1859, the site at Abbey Craig was agreed. A fundraising campaign was established and a national competition organised for a suitable design. John T. Rochead's (1814–78) soaring Scottish baronial tower surmounted by an imperial crown was the winning entry.

The foundation stone was laid by the Duke of Athole, Grand Master Mason, among much ceremony and in front of a crowd estimated at 80,000 on 24 June 1861.

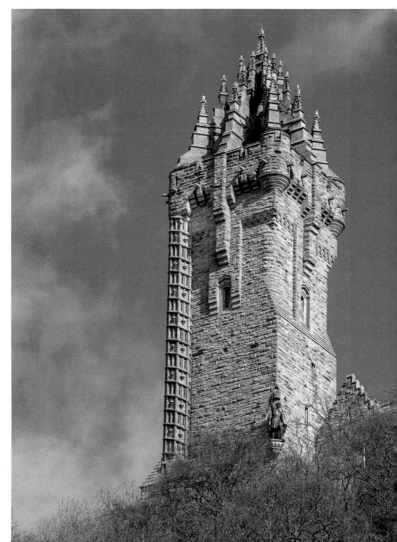

The National Wallace Monument.

The monument opened on 11 September 1869, the 572nd anniversary of Wallace's great victory at Stirling Bridge.

> In our estimation it would be impossible to find a situation in all respects more suited for a national monument, or better adapted for a memorial cairn to the national hero. Abbey Craig is geographically in the centre of Scotland; it is likewise the centre of the Scottish battleground for civil and religious liberty. It overlooks the field of Stirling Bridge, where Wallace obtained his greatest victory; and the monument will surmount the spot where he is believed to have stood while surveying the legions of England crossing the bridge, in their path to destruction.
>
> Revd Dr Rogers
> Extract from a brochure on the opening of
> the National Wallace Monument (1861)

> Here we feel elevated, as if by enchantment, in the midst of a fairy scene, a panorama of the most ennobling character. Around is a level plain, watered by the silvery courses of the river Forth and guarded at almost every point by stupendous mountains. For miles on every side, everything is picturesque, beautiful, or sublime, there being not one single feature to mar the loveliness of the landscape or detract from the poetry of the scene.
>
> Revd Dr Rogers
> *A Week at Bridge of Allan* (1853)

There is a spectacular panorama from Abbey Craig towards Stirling, with the 'silvery Forth reposing, serpent like, in the centre of the plain'. The fertile soil in the meanders or links of the Forth at Stirling gave rise to the old rhyme: 'A crook o' the Forth is worth an Earldom o' the north.'

View from Abbey Craig.

# 15. Battle of Bannockburn Visitor Centre

The innovative new Battle of Bannockburn Visitor Centre was opened on 1 March 2014, in the 700th anniversary year of the battle. The competition-winning design was by Scottish architecture firm Reiach & Hall, and the project was managed by the National Trust for Scotland in association with Historic Scotland. In addition to the new visitor centre, the project also involved the repair and restoration of the main battlefield monuments and improvements to the landscape setting. The new visitor centre replaced an earlier facility that dated from the 1960s.

The textured grey brick walls and austere, geometric lines of the building reflect traditional Scottish rural architectural forms, and the pattern of the brickwork hints at the appearance of chain mail. The light and airy interior is arranged around a central courtyard with a café area and shop. The focus is the state-of-the-art immersive displays of the battle, which was a critical event in the history of Scotland.

Bruce and de Bohun, were fightin' for the croon
Bruce taen his battle-axe and knocked de Bohun doon.

King Robert was ill mounted, carrying a battle-axe, and, on his bassinet-helmet, wearing, for distinction, a crown. Thus externally distinguished, he rode before the lines, regulating their order, when an English knight, who was ranked amongst the bravest in Edward's army, Sir Henry de Boun, came galloping

Battle of Bannockburn Visitor Centre.

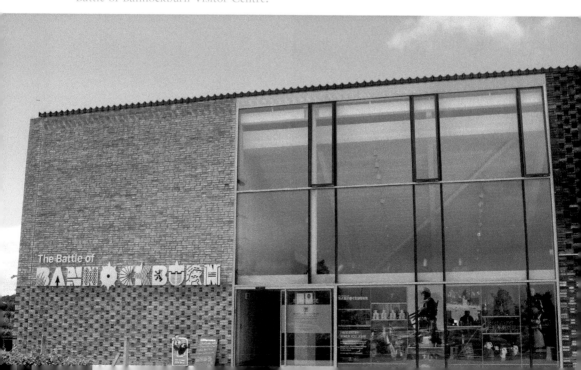

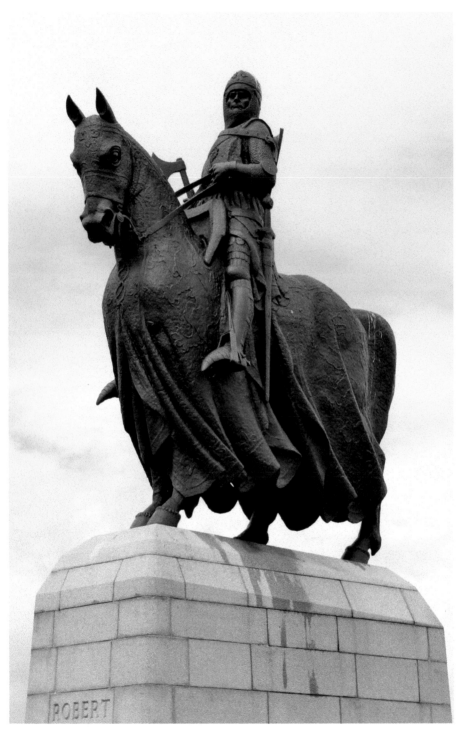

Statue of Bruce.

furiously up to him, to engage him in single combat, expecting, by this act of chivalry, to end the contest and gain immortal fame. But the enterprising champion, having missed his blow, was instantly struck dead by the king, the handle of whose axe was broken with the violence of the shock.

William Nimmo
*History of Stirlingshire* (1880)

The Battle of Bannockburn, on 23 and 24 June 1314, was a famous victory for the Scots against the vastly superior invading army of King Edward II. The victory secured Robert the Bruce's reputation as one of the great heroes of Scottish history and Scotland's future as an independent nation.

Tradition has it that the Scottish standard at Bannockburn was raised on a circular millstone, which is known as the Borestone. It became an emblem of national pride for many Scots and a target for early memento hunters who chipped off parts of the stone as keepsakes. The stone was later protected by an iron grille and, in 2014, the remaining two pieces were moved inside the new visitor centre. The original site of the Borestone is marked by a bronze B-shaped plaque.

The flagpole at the site was erected in 1870 by the Dumbarton Loyal Dixon Lodge of the Independent Order of Oddfellows. The rotunda that surrounds the cairn and flagpole includes lines from Kathleen Jamie's poem, 'Here Lies Our Land'.

The bronze equestrian statue of Bruce at Bannockburn, by the sculptor Charles d'Orville Pilkington Jackson, was unveiled in 1964 by HM the Queen on the 650th anniversary of the Battle of Bannockburn.

# 16. Cambuskenneth Abbey

The minster [at Cambuskenneth] was 178 feet long and 37 feet broad; it consisted of a nave, with only a single north aisle; a choir and a transept, with an east aisle; their foundations remain, with those of the chapter-house and refectory. The massive detached tower of four stories, Early English, 35 feet square, remains, with the west doorway of the nave in a wall. The site of this solitary tower is most beautiful, almost surrounded by the windings of the Forth, and fine trees; whilst the grand elevation of Stirling on its commanding height, with many spires, a castle, and the steeple of the Grey Friars Church on the south, and the wooded Abbey Crag on the east (now disfigured by the Wallace monument), partly frame the view. Many interesting associations pleaded for its preservation. In 1308, the barons swore at the high altar to defend the title of Robert Bruce. The first Scottish Parliament, with representatives of the cities and burghs, was assembled within the convent walls. Edward I was here November 1, 1303, and March 5, 1304. In 1326, Richard II of England is said to have died a prisoner in Stirling Castle, after a captivity of eighteen years, and probably worshipped here; and in the same year the National Assembly swore fealty to the line of Bruce, in the presence of King Robert, who came to witness

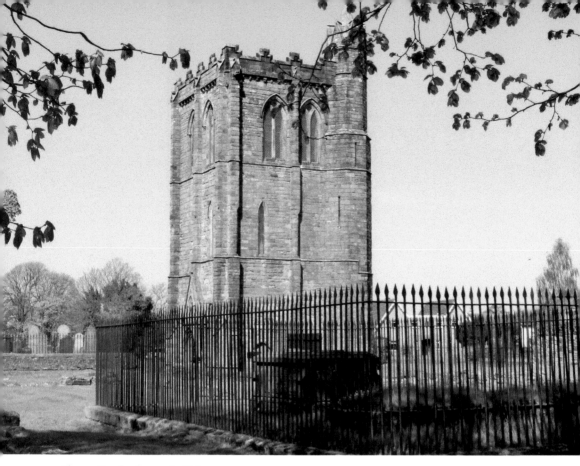

*Above*: Cambuskenneth Abbey.

*Below*: Tomb of James III.

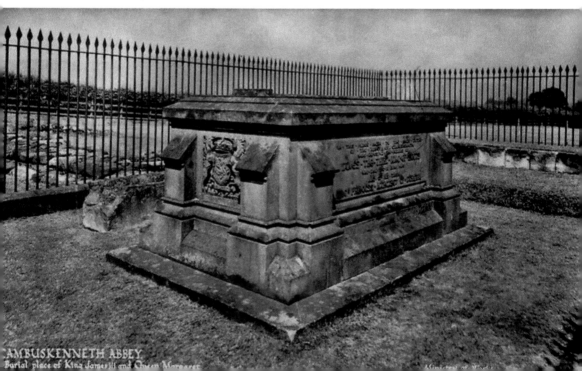

CAMBUSKENNETH ABBEY
Burial place of King James III and Queen Margaret

the marriage of his sister Christian to Murray of Bothwell. James III, who died June 11, 1488, and Queen Margaret of Denmark were buried here, and her Majesty Queen Victoria erected a tomb to their memory in 1865.

Mackenzie Walcott
*The Ancient Church of Scotland* (1874)

We have authentic data that the Abbey of Cambuskenneth was built in the year 1147, and founded by King David I. It was situated in a most pleasant and fertile peninsula of the Forth, about one mile east of the town. Many of the ecclesiastics of this Abbey were remarkable for their piety and learning. Few vestiges of the houses of the ancient ecclesiastics can now be traced out. The only remnant that exists entire is the belfry tower, a portion of the garden, a burying-ground, and a considerable extent of the foundation walls. This Abbey was richly endowed for a religious fraternity of St Augustine, or canons regular, and called the monastery of Stirling, and was dedicated to St Mary.

John Forbes
*The Tourist's Companion Through Stirling* (1848)

Cambuskenneth Abbey was established by David I in 1147 for canons brought from Aroise Abbey in Artois as a dedication to the Virgin Mary. It was originally known as the Abbey of St Mary or the Abbey of Stirling. It was one of the wealthiest and most important abbeys in Scotland due to its royal connections and proximity to Stirling Castle. At its height the abbey comprised an extensive complex of buildings.

The abbey's closeness to Stirling Castle put it in the way of attack during the Wars of Independence. In 1383 it was largely destroyed by the army of King Richard III and it was rebuilt during the early 1400s. It was also the scene of several significant historic events; in 1314 King Robert I held a Parliament at the abbey following the Battle of Bannockburn.

The abbey was abandoned in 1559 during the Scottish Reformation, with stone removed for building work in the town, including Mar's Wark.

The abbey is reduced to its foundations except for the dramatic three-storey square bell tower, which dates from 1300 and is considered to be the finest surviving medieval bell tower in Scotland.

The elaborate tomb on the site marks the last resting place of James III, who was murdered near Bannockburn after fleeing the Battle of Sauchieburn on 11 June 1488. He was interred in front of the high altar of the abbey church alongside his queen, Margaret of Denmark, who died in 1486. The tomb was paid for by Queen Victoria following the discovery in 1865 of two coffins, which were presumed to be those of the royal couple.

# 17. Airthrey Castle

Records of the Airthrey estate date back to the twelfth century, and over the centuries it passed through the ownership of several noble families. In 1759, the estate was

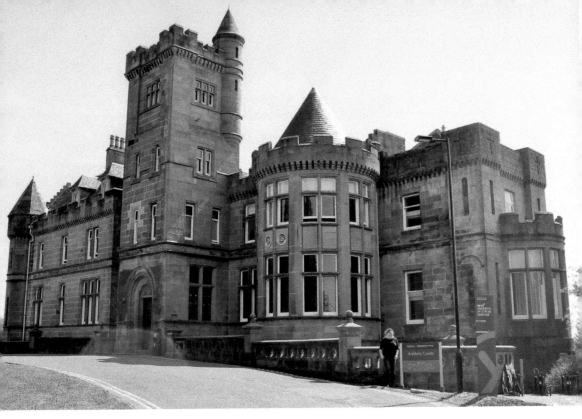

Airthrey Castle.

sold to the Haldane family, who commissioned the landscaping of the grounds by Thomas White and a new house by Robert Adam, which, despite later additions, still forms the core of the present building. The castle functioned as a maternity hospital during the Second World War and continued in this use until 1969, allowing a few locals of a certain age to claim that they were born in a castle. The Airthrey estate now forms the campus of the University of Stirling.

# 18. Falkirk Steeple

The High Street has long been the main thoroughfare of Falkirk. It was first laid with causey setts in 1851 and was pedestrianised in the mid-1980s. Although it seems that the Falkirk Bairns had previously imposed their own form of pedestrian priority – one account of Falkirk noting that: 'pedestrians in Falkirk', local and visiting, accept the fact that High Street pavements are narrow and meet the difficulty by walking unconcernedly in the street, to the visible alarm and bewilderment of motorists passing through the town, who have not elsewhere encountered this phenomenon.

Revd Wilson S. Leslie
Third Statistical Account (1951)

The iconic symbol of Falkirk and the dominating feature of the High Street is the 43-metre-high (141 ft) steeple with its octagonal stone spire and clock. The current steeple dates from 1814 and is the third incarnation of the famous Falkirk landmark.

Falkirk's first steeple was built in the late sixteenth century. Its precise location is unknown, but it is suggested that it stood at the junction of Manor Street and Kirk Wynd. It is recorded that it was demolished in 1697 due to its ruinous and unsafe condition. In the same year a new steeple attached to the front of the tolbooth was built.

In 1801, William Glen, a local businessman, was given permission to demolish the old tolbooth to the east of the steeple and rebuild on the site. The new building shared a wall with the steeple and a few years later, in 1803, the steeple started to subside, and cracks appeared in the stone – demolition was the only option.

There ensued a long legal conflict and it was ten years before the architect David Hamilton was commissioned to design a new steeple. In 1812, the Falkirk Stentmasters launched an appeal to raise the funds required for the work. By June 1814, the grand new steeple was complete. In 1815, a local clockmaker fitted the clock, an essential feature at a time when few people owned watches.

From the early seventeenth century, the Stentmasters or Stint-masters (in Old Scots, Stent means an assessment of property for taxation and derives from the Old French *estente* – valuation) were responsible for collecting rates according to the 'means and substance' of the individuals and maintaining the infrastructure of the town. They were also responsible for the fire engines, paying someone to ring the town bell and appointing a town drummer. The establishment of the town council, under the Municipal Reform Act of 1833, which was followed by the Police and Improvement Act of 1859, finally removed the powers of the Stentmasters and Feuars.

> Falkirk Town Steeple, which has been a familiar and popular landmark with the people of the locality for more than a century was partially destroyed yesterday afternoon through being struck by lightning in the course of a short, sharp thunderstorm. Located as the building is in a central position on the High Street and surrounded by shops and tenement properties, the occurrence naturally created considerable alarm and excitement, but, fortunately, it was unattended by any loss of human life. This circumstance is all the more remarkable when regard is had to the fact that something like forty feet, representing the major portion of the fifty feet Ionic spire, collapsed and crashed into the street and through the roofs of adjoining tenement dwellings. The outstanding feature, indeed, apart from the highly alarming nature of the occurrence, was the positively miraculous escapes from serious injury or death of the tenants occupying the premises struck by the falling masonry.
>
> Falkirk Herald (18 June 1927)

On Friday 17 June 1927 at 2.10 p.m., a large part of the upper part of the Falkirk steeple was brought down by a lightning strike. There were reports of a blinding flash of lightning, followed by a reverberating clap of thunder and the almost simultaneous crash of the falling steeple. Massive blocks of stone fell with a deafening roar to the street, windows in the locality were shattered and fragments of the fallen masonry ricocheted over housetops into streets a hundred yards from the steeple. The weathervane was discovered in a court on the north side of the High Street. Fortunately, there was a torrential downpour of rain immediately before the thunderbolt struck, which sent pedestrians on the street running for shelter.

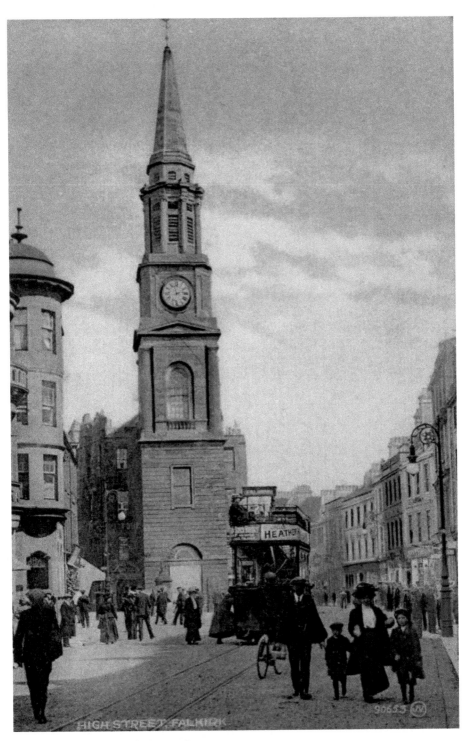

*Above and opposite*: Falkirk Steeple.

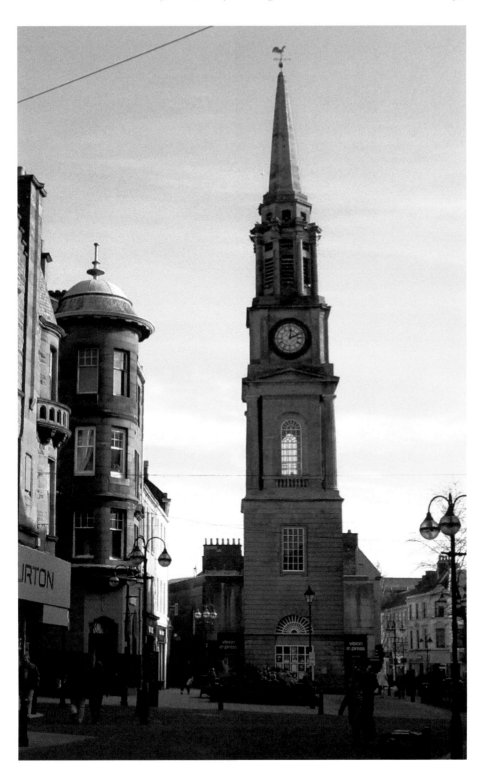

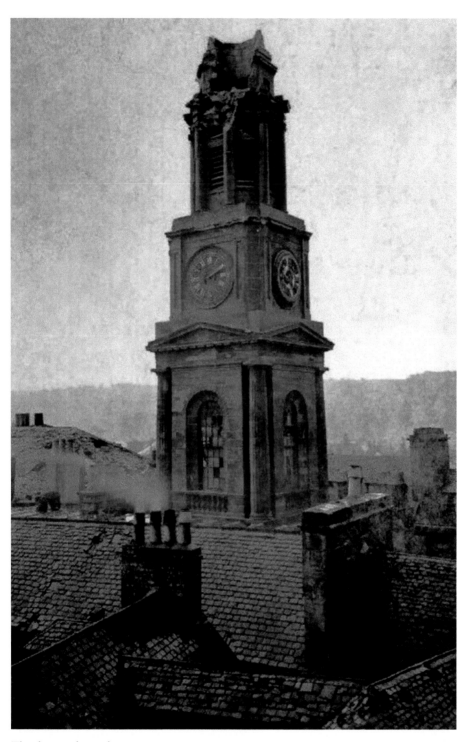

The damaged steeple.

Eyewitnesses described being blinded by an enormous flash and, looking up at the clock just as the lightning struck near the top of the steeple, a great cloud engulfed the building and, when the cloud cleared, the steeple was in a 'beheaded state'.

John McOrnish of Sunnyside, Camelon, had a miraculous escape. He was delivering Barr's aerated waters, with his horse-drawn lorry, to a shop on the north side of the steeple when plaster rained down on him. He was stunned by 'an awful boom', but managed to run to the west side of the steeple. He noted that he had served in France and had never heard a shell burst like it. He just missed being struck by a block of stone, which sadly killed his unfortunate horse, Carnaver.

Stones fell through the roof of the Steeple Land, a tenement next to the steeple. Mrs Barr, who was in the top flat with her two children (Andrew and Jamie), had a particularly terrifying experience. They were practically buried under the falling masonry and were rescued when neighbours forced open the door of the flat. Mrs Barr described being blinded by a flash of light and thunder shaking the house. They were fortunate to escape with only minor injuries and only six or seven people required the attention of a doctor after the incident. Several other buildings were damaged, and the Falkirk Fire Brigade had to deal with a fire at the Universal Bar caused by fused electrics.

The news of the event travelled fast, and thousands of people gathered on the High Street to view the scene. They were kept at a safe distance by the police until barricades were erected later in the day. Steeplejacks were employed to remove loose stone down to the level of the clock and the crowd watched them with bated breath as they removed masonry and threw it down to the street. While they were working a collie dog wandered into the danger zone and the hush of the huge crowd was broken by whistles and calls to the dog. However, one of the steeplejacks threw down some small stones to scare it off. By 10 p.m., most of the dangerous masonry had been removed and one of the steeplejacks 30 metres (100 feet) above the ground was noted as stunning the crowd of onlookers: 'as cool as the proverbial cucumber, dusting his hands and kicking away a small stone, as he would have a banana peel on the pavement.'

A special meeting of the Town Council was held in the Burgh Buildings the following day to agree steps to have the area made safe as quickly as possible and accommodate the five families from the severely damaged Steeple Land – until 'all cause for anxiety and danger has been removed'. It was noted that every true Bairn felt as though 'grievous bodily harm had been done to an intimate personal friend'. In the aftermath of the event, many locals were said to be suffering from 'kink-in-the-neck', due to the constant habit of looking up to view the damage to the steeple. There was also many a call of 'hunt the gowk', when people looked up to check the time on the missing clock.

It seems that money could not be taken from the rates for the restoration work and a subscription fund, with a target of £2,500, was set up to restore the steeple. Falkirk Bairns from home and abroad donated to the fund and by March 1929, the restored Cock o' the Steeple was once again sitting proudly on its perch at the pinnacle of the rebuilt spire. It was noted that Mr Robert Dollar of San Francisco had donated £200 towards the provision of a new clock. The old clock and two of the faces were restored and are now in the care of the National Museum of Scotland in Edinburgh.

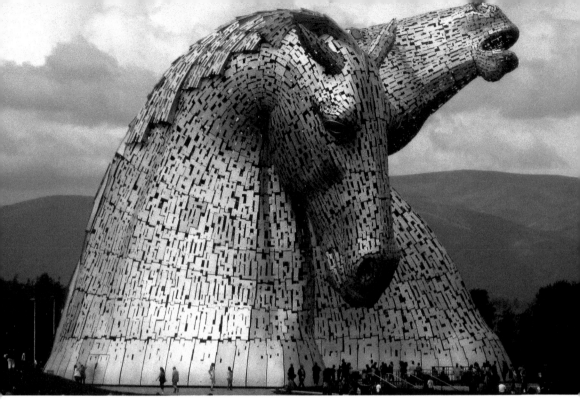

*The Kelpies.*

## 19. *The Kelpies*

The 350-hectare Helix Park was opened in the summer of 2014 with the two strikingly beautiful 30-metre-high (98 ft) steel sculptures of the Kelpies as its centrepiece. *The Kelpies* link the mythical Scottish water spirit with the heavy horses that were the historic sources of power for industry, transport and agriculture.

## 20. Callendar House

Callendar House, with its 91-metre-long (300 ft) frontage, is the most noteworthy historic structure in Falkirk.

The Callendar estate was granted to the Livingston family in 1345, and it was the family seat of the earls of Callendar and Linlithgow for nearly 400 years. The Livingstons were close to Mary, Queen of Scots and the queen was a guest at Callendar several times. In July 1651, Cromwell's forces laid siege to the garrison at Callendar House, which attempted without success to hold the building in the

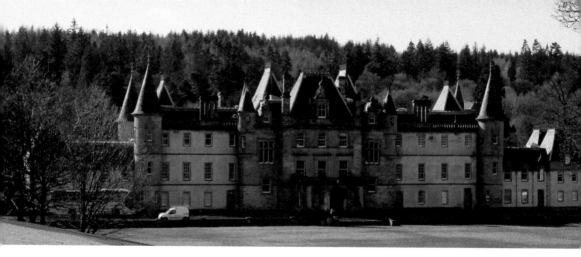

*Above*: Callendar House front façade.

*Below*: Callendar House rear façade.

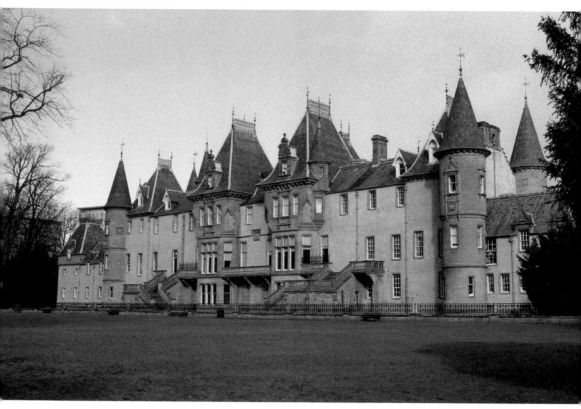

name of the king. The Livingstons lost the estate in 1715 due to their allegiance to the Jacobite cause.

In 1783, the estate was bought by William Forbes, who had made a fortune copper bottoming the keels of ships – hence his nickname Copperbottom. Forbes was responsible for the remodelling of the house into the outstanding French Renaissance-style building that exists today.

Forbes made several changes to the estate that upset the locals. In August 1797, there was a boisterous demonstration near the estate, which Forbes though was the Falkirk mob advancing on the house with ill intent. He took flight and mistook the flames of Carron Ironworks for a torched Callendar House. His actions were savagely lampooned in a contemporary caricature.

The Forbes family considered that the construction of the Union Canal would spoil their view and disturb their privacy. Their objections were vociferous, and the canal builders were forced to run the canal in a 631-metre (690 yard) tunnel in the vicinity of Callendar House. Known as the Dark Tunnel, it remains an impressive monument to the technical skill of the engineers and the back-breaking toil of the navvies, who came mainly from the Highlands and Ireland to work on the canal.

The Callendar estate remained in the ownership of the Forbes family until it was sold to the local authority in 1963. High-rise flats and the short-lived (1964–81) Callendar Park College of Education were built in part of the grounds.

The house remained disused and in a semi-derelict condition until it was fittingly restored as an excellent museum in 1997. The huge, landscaped gardens are now a fine public park incorporating a boating lake, children's play area and a stretch of the Antonine Wall.

# 21. The Antonine Wall

During the Iron Age, a tribe known as the Manau or Maeatae inhabited the area around Falkirk. However, it was the Romans that were the first to make a significant mark in the Falkirk area when Emperor Antoninus Pius ordered the construction of the Antonine Wall, the Vallum Antoninior Graham's Dyke, spanning the 63 kilometres (39 miles) from the Forth to the Clyde in around AD 142. The plan was to keep the troublesome Caledonian tribes on the north of the wall.

The wall marked the most northerly frontier of the Roman Empire and was an outstanding monument to the engineering prowess of the Roman army. Its construction over a twelve-year period involved the building of a turf rampart on a stone base, which was protected by a broad V-shaped defensive ditch and low mound.

The Antonine Wall was abandoned in AD 164 when the Roman army withdrew from Scotland, pulling the northern frontier back down to Hadrian's Wall. After invasions from the north in AD 197, the emperor Septimius Severus arrived in AD 208 to restore order along the Scottish Borders, briefly reoccupying and repairing portions of the wall. However, after only a few years the Antonine Wall was abandoned permanently and the main Roman defensive line reverted south to Hadrian's Wall. Its turf construction meant that little of the wall remains. The Roman fort at Falkirk was in the Pleasance. In 2008, the international importance of the wall was recognised by its designation by UNESCO as part of the Frontiers of the Roman Empire World Heritage Site.

The Antonine Wall at Callendar Park.

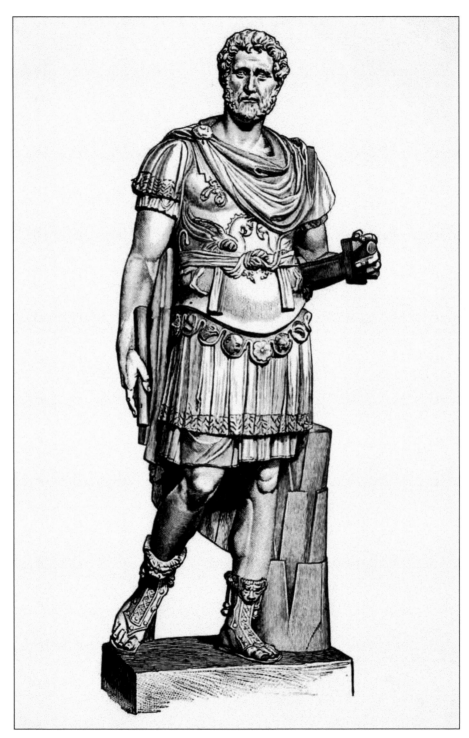

Emperor Antoninus Pius.

# 22. The Canals

Central Scotland's canals come together at Camelon. The Edinburgh & Glasgow Union Canal was approved by an Act of Parliament in 1817, construction began at the Edinburgh end in 1818 and it was opened in 1822. The canal originally ran 31 miles from the Port Hopetoun Basin in Edinburgh to Falkirk. It was 5 feet deep, followed a land contour throughout its length and required no locks, which required significant engineering works, such as the massive Avon Aqueduct.

The Forth and Clyde Canal, originally known as the Great Canal, the oldest and longest canal in Scotland, was authorised by an Act of Parliament in 1768. It was a remarkable feat of engineering at 62 kilometres (39 miles) long. Construction began at the east coast in June 1768 but stalled several times. It was finally opened in July 1790, linking Falkirk to Port Dundas in Glasgow.

The advantages of canal transport were clear – a horse could pull 50 tons on the canal, but only 2 tons on the road – and industry boomed along the canal. A flourishing passenger service also ran on the canals between Edinburgh and Glasgow. From 1831, it was possible to take a bunk on the night boat passenger service, known as 'hoolits' (from owls), for the journey. By 1836, around 200,000 passengers per annum were using the canals for journeys between the two cities. Edinburgh to Glasgow took six and a half hours with boats towed by two horses. In 1841, it cost 6s (cabin fare) or 4s (steerage) to travel by Swift Passage boat between the cities.

Lock 16.

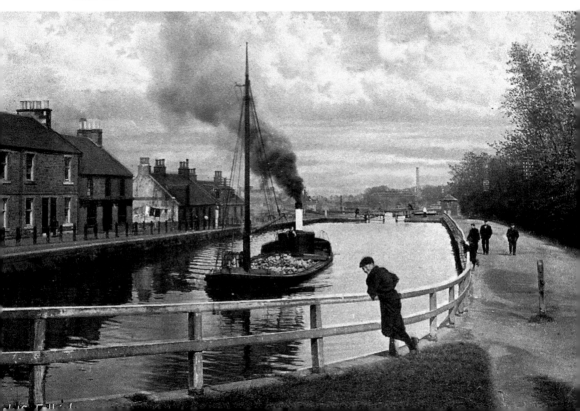

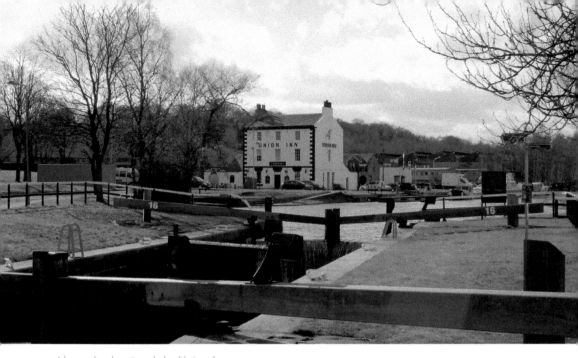

*Above*: Lock 16 and the Union Inn.

*Below*: The Union Canal.

1840–41 probably marked the peak of the passenger traffic, with five boats leaving Glasgow for Edinburgh every weekday, supplemented by three night boats.

The Port Downie Basin was a busy interchange where goods were offloaded for road transport to neighbouring towns and villages. The Union Inn at Port Downie is a fine example of an early nineteenth-century trading post inn. It dates from the time of the completion of the Union Canal in 1822. Travellers could disembark and take refreshments at the Union Inn at Port Downie while barges passed through the chain of locks that linked the two canals. Its location, at what was a pivotal trade point where the Forth and Clyde and Union Canal joined, made it one of the best-known hostelries in Scotland in its heyday.

The Forth and Clyde and Union canals suffered, like most canals, from railway competition. The opening of the Edinburgh and Glasgow Railway in 1842 drastically reduced their importance and they fell into a slow decline.

# 23. The Millennium Link – The Falkirk Wheel

The Forth and Clyde Canal and the Union Canal were originally connected at the Port Downie Basin, beside Lock 16, by a series of eleven locks that climbed 33.5 metres (110 feet). The locks were removed in 1933. The ambitious Millennium Link project in the 1990s involved the renovation and reopening of the two canals.

The Falkirk Wheel.

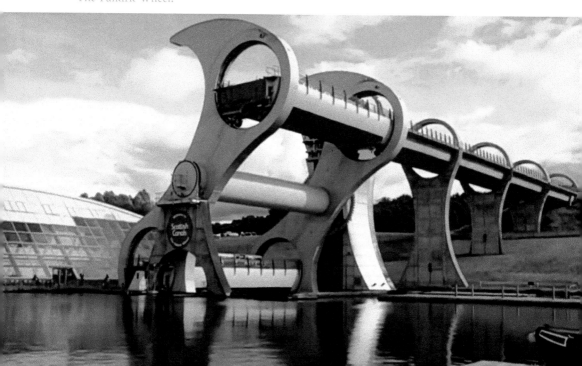

The solution to the restoration of the connection between the two canals was the Falkirk Wheel. Opened in 2002, the revolutionary wheel is a spectacular engineering marvel and the only boat-lifting device of its kind in the world.

# 24. Carron Ironworks

In 1782, the Carron Company erected a water-engine which, for its dimensions and capabilities was looked upon as one of the wonders of Scotland – it worked at seven strokes a minute and could lift 3,500 gallons at one stroke and consumed 16 tons of coal in 24 hours.

<div align="right">

Samuel Griffiths
*Guide to the Iron Trades of Great Britain* (1873)

</div>

Scotland's first major iron foundry was established on the north bank of the River Carron in 1759. The site had a convenient water supply and a local source of iron ore from Bo'ness. Carron Company was at the forefront of the Industrial Revolution and was the engineering showpiece of Scotland. It was to become the largest ironworks

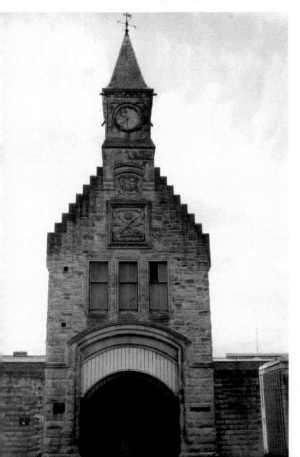

The clock tower at Carron Ironworks.

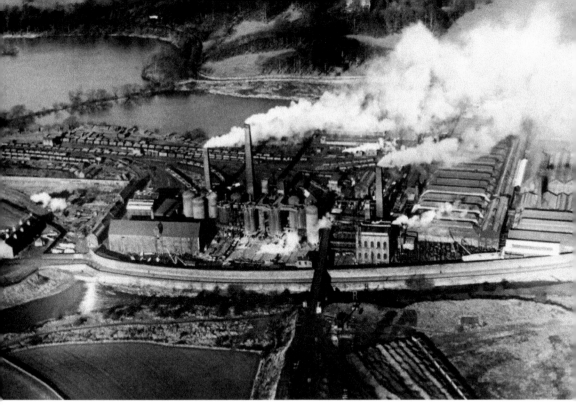

Carron Ironworks in its heyday.

in Europe, with over 2,000 workers, and was immensely important in the fortunes of Falkirk. The ironworks attracted thousands of skilled workers to the area – so many from England that it became known as the 'English Foundry'. The company was renowned for its armaments but also manufactured stoves, kitchen ranges, garden and kitchen implements, baths, grates and the famous red telephone boxes. The worldwide influence of the company is reflected in the continued use of a cast-iron cooking pot in parts of Africa, which is still known as the Falkirk Pot.

The scale of the business was huge. The company had its own network of railway lines connecting its mines to its foundries and the Carron Shipping Line was established in 1772 to ensure dependable delivery of the company's goods. Falkirk developed as a hub for iron casting with over twenty foundries setting up adjacent to either the canal or the railway.

Carron Works' Carronade was a small-barrelled naval cannon that was shorter and lighter than standard. It meant that it was easier to load, manoeuvrable and more could be carried on ships. It was used to great effect in numerous naval and military campaigns. It was originally known as the 'Gasconade', after Charles Gascoigne, a partner in the company, but was better known by its later name, the 'Carronade'. The Carronade remained in production from 1778 through to the 1850s and established Carron Company's worldwide fame and reputation for quality. Lord Nelson and the Duke of Wellington both insisted on using cannon cast at Carron. Carron Works continued to produce munitions in both world wars.

Working conditions in the foundries were hard, with boys as young as nine working at the furnaces. It was scorching and grimy work. Heavy ladles of boiling molten iron were carried from the furnace to sand moulds by pairs of men known as

neebours – it was said that you could tell which side of the mould that they carried by the way they leaned to one side or the other when walking home.

The central gabled clock-tower is all that remains of the long range of buildings which formed Carron Company's offices on Stenhouse Road, following the demolition in 1990. The tower forms a curious local landmark and acts as a reminder of the important contribution that Carron Company made to the industrial revolution. The gated area on the ground floor of the tower displays examples of Carron Company's ordnance production – two heavy cannon, which were used at the Battle of Waterloo, and two Carronades. The frontage of the tower also includes an iron lintel from the first blast furnace on the site, dated 1760, and a cylinder cast dated 1766 for James Watt's steam engine. The upper level stone carving shows the company's crest with crossed cannons and a phoenix rising from the flames with the company motto above, `Esto Perpetua' (Let it Endure Forever).

# 25. The Dunmore Pineapple

The first encounter between a European and a pineapple occurred in 1493, when Christopher Columbus went ashore on the Caribbean island of Guadaloupe where the sailors ate, enjoyed and recorded the curious new fruit. Reports and later samples of the New World's pineapple made it an item of curiosity for both gourmets and horticulturists. However, despite strenuous efforts by European gardeners, it was nearly two centuries before they were able to perfect a hothouse method for growing a pineapple plant.

The pineapple became a celebrity fruit; its rarity, expense, reputation and attractiveness making it the ultimate exotic food item. The pineapple literally crowned the most important feasts, often held aloft on special pedestals as the centrepiece of the dining table. So sought after were the prickly fruits that they were rented to households by the day. Later, the same fruit was sold to other, more affluent clients who actually ate it. Into the 1600s, the pineapple remained so uncommon and coveted a commodity that King Charles II posed for an official portrait in which he is receiving a pineapple as a gift, an act then symbolic of royal privilege.

The pineapple as a symbol of wealth and generous hospitality led to its adaptation as a motif for architects, artisans and craftsmen. Sculpted pineapples appeared as gateposts, weathervanes, and door lintels. They were stencilled on walls, woven into tablecloths, napkins, carpets and curtains, and painted onto the backs of chairs and tops of chests. However, the use of the pineapple motif in architecture reached its climax in the colossal stone Pineapple structure at Dunmore Park, which is probably one of the most fantastic buildings in Scotland.

Constructed, by the fifth Earl of Dunmore as a garden folly, with a keystone dated 1761, the Pineapple is built into the north wall of the walled garden, where it forms a focal point, standing 45 feet above ground level. It is a remarkably accurate rendering of a pineapple, with each of the gently curving leaves being drained separately in order to prevent frost damage to the delicate masonry. The Pineapple

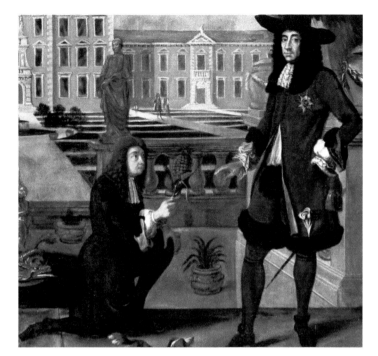

*Right*: King
Charles II being
presented with a
pineapple.

*Below*: The
Dunmore
Pineapple.

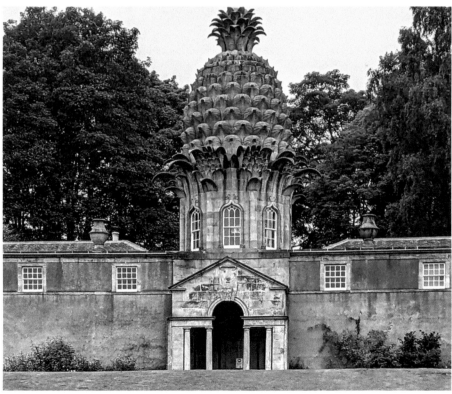

more than lives up to its description as a 'classical essay of novel conception', with its ingeniously constructed and incredibly realistic massive stone leaves cantilevered out from the main structure. Pineapples were scarcely seen at this time except by the very rich, so this stone copy must have astounded and bemused the local population.

Pineapples had been grown in Scotland from the early eighteenth century and were cultivated at Dunmore in hothouses against the walls of the garden. The walls are of a double brick construction with an air gap and this allowed hot air to circulate for the benefit of the fruit trees.

The architect of the Pineapple is unknown. Tradition ascribes it to Sir William Chambers, who designed similar work at Kew Gardens, but he was working in London at the time it was built, and it is not mentioned in his writings, as such a remarkable building surely would have been. The National Trust for Scotland now owns the Pineapple and it can be rented as a very unusual holiday home from the Landmark Trust.

# 26. Torwood Castle

We now approach the scattered oaks of Torwood [wood on the eminence] the remains of the Silva Caledonia or ancient Caledonian Forest. This forest, according to Boyce, covered the country onwards from this vicinity, by Menteith and Strathearn, to Athole and Lochaber, and was chiefly tenanted by white bulls, with shaggy hair and curled manes, which were remarkable for their untameable ferocity. Attacked by the hunter, their resistance was desperate; and if overcome and captured, such was their alleged abhorrence of their captor, that they refused to eat any food which he had handled. A footpath conducting westward from the tollbar at Torwood, through a park of young oaks, after an ascent of half a mile, gains the ruin of Torwood Castle, situated on an eminence, surrounded by stately and venerable trees. This structure, which is unroofed and considerably dilapidated, though retaining the aspect of original importance and strength, has its history involved in obscurity. The estate on which it is situated was long in the possession of the family of Baillie, till at length it came by marriage into the possession of the first Lord Forrester, whose son, the second lord, sold it to the grandfather of the present proprietor, Colonel Dundas of Carron Hall. The vicinity of the castle was in former times the resort of persons subsisting by highway robberies and nocturnal depredations, now it is the scene of picnics and the favourite lounge of parties of pleasure.

<div align="right">

Charles Rodger
*A Week at Bridge of Allan* (1853)

</div>

Torwood was originally a much larger area of dense forest. In 1314, Sir James Douglas, one of the leaders of the army of King Robert the Bruce (1274–1329),

encamped at Torwood prior to the Battle of Bannockburn. It is also associated with William Wallace (1270–1305), who, legend has it, hid in the hollow trunk of an enormous oak tree in the woods and used it as his headquarters. Over the centuries, the tree was targeted by souvenir hunters and was lost by the late nineteenth century. A section of the Roman road, the Camelon Causeway, also passes through the woods.

Torwood Castle stands today as a semi-ruinous L-plan tower house. It has been dated to 1566, based on an inscribed stone found nearby in 1918, and was the ancestral home of the Forrester of Garden family. The Forresters were the hereditary keepers of the Royal Forest of Torwood. In 1585, the castle was occupied during the rebellion by the earls of Angus and Mar, as they prepared to attack Stirling Castle. From the mid-eighteenth century, the castle passed through the hands of several owners and fell into a state of disrepair.

The castle was purchased by a private individual in 1957, who carried out work on the structure and established a trust for the restoration of the building. Several enthusiastic volunteers continue to work towards securing the future of the castle. It is a rare and significant relic of the area's historic past and is deserving of appropriate restoration.

A short walk south of the castle leads to the Torwood Blue Pool. The circular pool is lined with brick and is 20 feet in diameter and around 15 feet deep. There are several theories about the pool; the most likely is that it is a ventilation shaft for a mine in the local area.

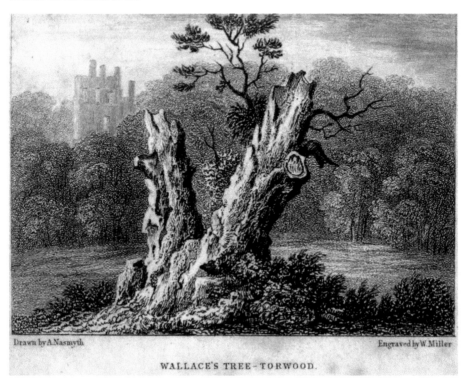

Drawn by A.Nasmyth        Engraved by W.Miller

WALLACE'S TREE - TORWOOD.

The Wallace Oak.

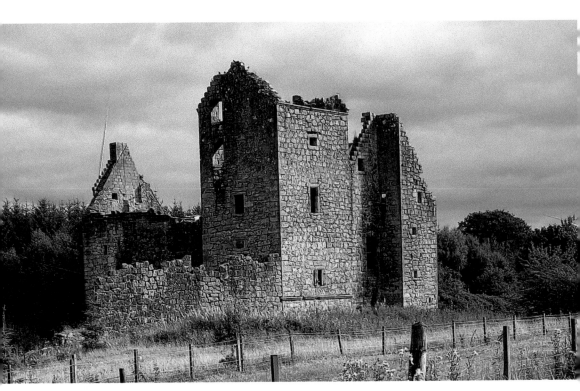

Torwood Castle.

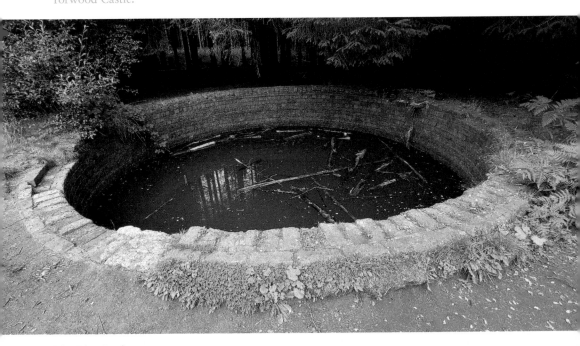

The Blue Pool.

# 27. Tappoch Broch

Interesting Antiquarian Discovery at Torwood. A curious and interesting antiquarian discovery has been made on Tappock Hill, in Torwood Forest. The discovery includes a large circular stone building entombed in an elevated mound, the upper portion of a Scottish quern, a small iron hammer of ancient make, with other historical remains. The proprietor of the land is Lieutenant-Colonel Dundas of Carronhall, and it is at his instance that the excavations have been made. The hill is covered with wood, and though its appearance from time immemorial has predicted the existence of something unusual, and the wonder therefore is that steps were not long since taken to have Tappock disembowelled. The structure has a diameter of 32 feet 6 inches and the height will be about 10 feet.

*Falkirk Herald* (27 August 1864)

Tappock is the highest point in the ancient forest of Torwood and commands an extensive view of the whole district lying between the Forth and the Carron, as well as of the distant country and mountains beyond those rivers. The mound at Tappock is known by the country people as the 'Roman Camp,' and a subterranean passage is supposed by them to lead from it to the old Castle of Torwood, about three-fourths of a mile distant – a famous haunt of Wallace.

Proceedings of the Society of Antiquaries of Scotland (1864)

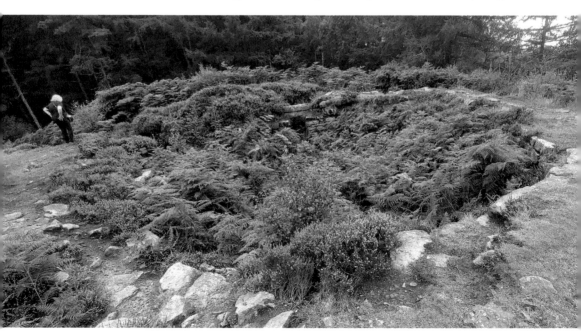

Tappoch Broch.

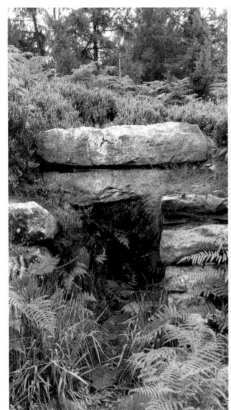

Doorway and steps, Tappoch Broch.

The Tappoch, or Torwood, Broch is well sign posted on the path that leads to Denovan from Glen Road in the village of Torwood. The remains of the broch consist of a large round chamber, with a central hearth, enclosed by 6-metre-wide roughly squared drystone walls. There is evidence of an entrance complete with a lintel and section of stair. In its original form the broch would have been cylinder shaped and up to 10 m or more in height. The courtyard would have contained timber framed structures surrounding the central hearth space.

Before the broch was excavated in 1864, at the behest of Colonel Joseph Dundas of Carronhall, it appeared as a mound. During the excavation over 200 tons of material was removed from the structure to reveal the inner wall and floor of the broch. The investigation at the time was undertaken in the belief that the structure was a chambered mound and no attempt was made to reveal the outer wall. The finds during the excavation included a stone cup, querns, boulders carved with cup-and-ring markings hollowed pebbles, stone balls and coarse pottery sherds.

Brochs are one of the most inventive and remarkable works of the Iron Age and are unique to Scotland. It is likely that the broch would have been a defensive feature at the centre of a small settlement. There are over 500 throughout Scotland, with most concentrated in Orkney, Shetland, Caithness and Sutherland and the Western Isles. They are a rare feature of the Central Lowlands.

# 28. Hills of Dunipace

Opposite the mansion of Dunipace are two singular eminences, of artificial formation, one on each side of the turnpike. These are the far-famed hills of Dunipace, the origin of which has been a theme of archaeological discussion since the era of Buchanan. The mound on the left, being the more westerly, is the larger of the two, and presents somewhat of an oblong or triangular form; the other, on the right, is of circular shape. Both are about the height of 60 feet. Buchanan asserts that they were raised in memorial of a peace concluded between the Romans under the Emperor Severus and the Caledonians, early in the third century, and that consequently a Latin and a Celtic word were used to certify the compact; hence the name Dunipace, from Dun, a hill, and Pax, peace. The accuracy of this narrative is now wholly questioned. The mounds are believed to be barrows reared at the close of some forgotten battle, in which were enclosed the piled heaps of the slain; and the Gaelic words Duin-na-bais, pronounced Dunipace, and signifying the hills of death, would seem to warrant the hypothesis.

<div style="text-align: right">

Charles Rodger
*A Week at Bridge of Allan* (1853)

</div>

The Hills of Dunipace are two prominent tree-covered raised mounds, amid the predominantly flat ground on the Denny Road to the west of Larbert. Several legends have been associated with the hills, the most prevalent being that they were raised to commemorate a peace treaty between the Roman Emperor Severus and local tribes or that they are burial mounds. These theories are said to account for the origin of the name Dunipace from Duni-pacis (hill of peace) or Dun-abas (hill of death). However, it is most likely that they are natural features and it has been suggested

Hills of Dunipace.

that the name Dunipace derives from Dun-na-peasg (the hill of the notch or cranny). The perimeter walls of the old churchyard, which contains some seventeenth century headstones, is beside the hills.

In 1787, Robert Burns noted that the site with 'the Carron running down the bosom of the whole makes it one of the most charming little prospects I have seen'.

# 29. Dunblane Cathedral, Cathedral Square, Dunblane

The cathedral of Dunblane (one of the few specimens of Gothic architecture which escaped to a great extent the ill-advised zeal of the Reformers) consists of a nave with aisles, a choir, a chapter-house, and a square tower. It is of small proportions, the nave being 130 feet in length, 58 in breadth, and 50 in height, and the choir 80 feet in length, 30 in breadth, and a little less than the nave in height. Without the elaborate decoration of Melrose, Dunblane excels in beauty of proportion and depth and force of moulding. The western double mullioned window, the beautiful little window in the gable, and the arcading of the triforium, are exquisite.

*Black's Guide to the Trossachs* (1883)

I know not anything so perfect in its simplicity and so beautiful, as far as it reaches, in all the Gothic with which I am acquainted.

John Ruskin (1853)

Dunblane Cathedral is one of Scotland's oldest ecclesiastical buildings and one of the finest examples of Gothic architecture in the country. It was founded in the mid-twelfth century; however, most of what can be seen today dates from the thirteenth century. The earlier red sandstone Romanesque bell tower was retained and increased in height by two storeys in around 1500.

The choir became the parish church following the stormy days of the Reformation in the sixteenth century and the nave was left unroofed. From 1889, Sir Robert Rowand Anderson completely restored the church, rescued it from a state of general dilapidation and returned the cathedral to its former glory. At a meeting of the Edinburgh Architectural Association on 8 March 1893, Anderson read a paper on his restoration of Dunblane Cathedral. He emphasised that the work was restricted to what was structurally necessary to stop it collapsing into a 'heap of ruins'.

Highlights of the interior include the six fifteenth-century richly carved timber choir stalls, the splendid traceried window on the east gable of the choir and outstanding late nineteenth- and early twentieth-century stained glass. A standing stone, inscribed with quotations relating to childhood, in the nave of the cathedral, is a poignant memorial to the tragic events of 13 March 1996 when sixteen local children attending Dunblane Primary School were killed by a gunman.

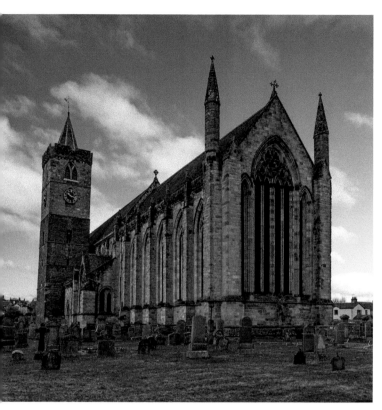

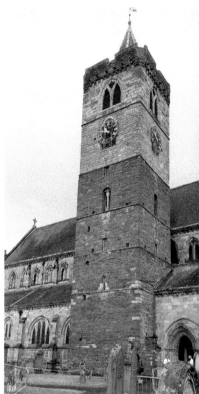

*Above left*: Dunblane Cathedral.

*Above right*: The bell tower, Dunblane Cathedral.

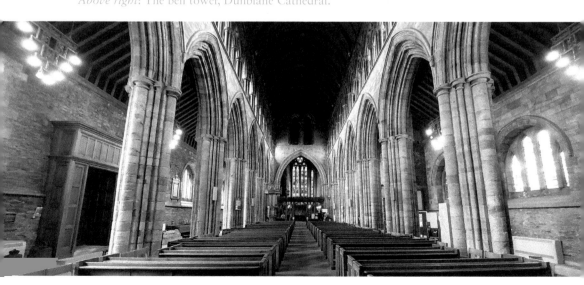

Interior of Dunblane Cathedral.

# 30. Dunblane Museum, The Cross, Dunblane

Sir John Stirling Maxwell formally opened the Dunblane Museum on 1 May 1943. Previous arrangements for its opening in September 1939 had been cancelled due to the outbreak of the Second World War. Representatives of the Society of Friends of Dunblane Cathedral were in attendance and many seats were provided outside the building. The building had been purchased by Mrs Stewart, who had it renovated and repaired for use as the museum. Sir John, who spoke from a bath chair, said that he would be disappointed if he was not offered a place in the museum as an antiquity. The label he suggested would read: 'Specimen of a Scots laird, dating from the mid-nineteenth or early twentieth century; not very well preserved and presented to the museum by the Hon. Mrs Stirling. We are hoping to replace the specimen by a better as soon as opportunity offers.'

Originally called the Dunblane Cathedral Museum when it opened, the museum now houses an extensive collection of objects, paintings, books and images focused on the cathedral and Dunblane. The museum's large collection of communion tokens is recognised as nationally important. The museum is staffed by a team of enthusiastic and knowledgeable volunteers.

The museum occupies a prominent site at the corner of The Cross and Kirk Street. The original parts of the building, fronting onto The Cross, were constructed for James Pearson, who was dean of the cathedral in 1624 (his initials and the coat of arms are on the carved plaque on the frontage). The Kirk Street section was built as

Dunblane Museum.

separate cottages in the eighteenth century. The group is an important early example of seventeenth-century domestic architecture incorporating two original barrel-vaulted ground-floor rooms and two sets of forestairs.

# 31. Dunblane Hydro, Perth Road, Dunblane

This is the height of the season in the hydropathic establishments, now so numerous and popular in Scotland. The number of them in this country is much greater in proportion to the population than in England. Most of them are on a large scale – capable of accommodating 100 to 250 guests at a time. There are well known establishments at Forres and Deeside in the north. Those at Pitlochry and Crieff, in the midst of the Perthshire Highlands, are much frequented at this season. In the south there are Melrose and Moffat, the most recently opened and the most commodious. The west coast has three – Rothesay, Wemyss Bay and Shandon. A new hydropathic house at Dunblane is intended. Two very large institutions of this kind are in course of erection on the south-west of Edinburgh – the one at Morningside, near the famous lunatic asylum, the other on the slopes of the beautifully wooded hill of Craiglockhart.

A tolerably extensive and varied experience of Scottish hydropathics has led me to the conclusion that they are frequented only to a limited extent by invalids of the class for which they are primarily intended. At all of them one does meet with cadaverous and sallow-faced individuals, who attend strictly to the regimen, who take the baths regularly and who dutifully sup on hot water and dry bread. But the number of those who are impelled by quite different motives – by a liking for comparatively cheap and on the whole comfortable living in the midst of picturesque scenery, and by the attractions of a free and easy and quasi-refined society – is certainly very much larger. Even of the confirmed individuals it is sometimes said, in good-humoured malice, that they are in the habit of supplementing their draughts of hot water at supper time by stronger potations in their private rooms.

The people you meet with are of all ages, of all professions and callings, and of very different social grades. The life is pleasant, and the cares of housekeeping are banished. In the spacious furnished drawing rooms, the forlorn bank clerk or the provincial shopkeeper may hob-nob with the railway director or the city clergyman; and the small farmer or rural manufacturer may have his ambitions warmed by seeing his wife and daughters share couches and exchange civilities with real ladies. It is, however, as a newly found and most successful matrimonial mart that the hydropathic seems destined to confer the greatest benefits to society.

*The Mail* (11 September 1878)

Speed to Dunblane with morning light.
And quaff the limpid spring that's there.
And, when returning strength has told
You might aspire to bolder deeds,
Go, seek a charm surpassing gold,
In strolling through her verdant meads.

Dr Ainslie
*Essay on the Dunblane Mineral Springs* (1834)

The Dunblane Hydro, designed by Peddie and Kinnear, occupies a grand Italianate building, which sits high on a hillside overlooking Dunblane and the surrounding area. The symmetrical palace-fronted design includes a tall central clock tower with a veranda and belvedere and projecting five storey flanking bays.

The Dunblane Hydropathic Establishment, as it was then known, was formally opened on 13 September 1898 with a ball attended by over 200 guests. It was a further addition to the burgeoning number of hydropathics, which were popular at the time and offered a wide range of hydro-therapeutic treatments. In 1898, advertisements for the Hydro noted that Dunblane is in the centre of magnificent mountain and lake scenery with 'a climate of noted salubrity'. The weekly charge was 2 and a half guineas.

Hotel residents were also able to partake of water from the local mineral springs. Peter Gordon Stewart, a local doctor, notes in his *Essay on the Dunblane Mineral Springs* (1834) that Dunblane was a popular destination with 'the congregated fashion of the world' based on the quality of its mineral springs, which had been discovered in 1813 and were said to be 'capable of curing all diseases'.

Competition from the numerous other hydropathic establishments resulted in the business entering receivership in 1884 and its conversion into a conventional hotel by the new owners. During the First World War, the hotel was requisitioned by the War Office as a military hospital and, at various times during the Second

Dunblane Hydro.

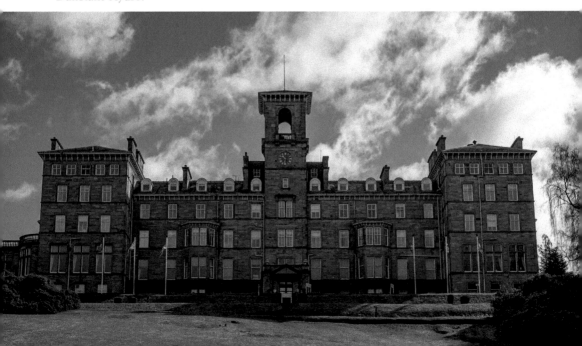

World War, it housed a boarding school evacuated from the south of England and a soldiers' convalescent home. In 1962, the Stakis group took ownership of the hotel and carried out a major refurbishment of the decaying building. The Hydro was sold to the Hilton Hotel Group in 1999 and opened in 2000 following a major refurbishment. It now operates as a DoubleTree by Hilton.

An original stained-glass window on the main staircase features 'Jessie, The Flower o' Dunblane' from the song by Robert Tannahill.

# 32. Leighton Library, The Cross, Dunblane

He (Robert Leighton) bequeathed his library to the clergy of the diocese of Dunblane; and his executors, being his sister, Sapphira, and her son, Edward Lightmaker, erected at their own expense, a house to contain the books, and mortified £300, the interest of which to go to a librarian, and to uphold the fabric, and to add to the books. Various additions by will and purchase have been made to the books. £100 of the mortified money have been expended on the repair of the house. The room has recently been fitted as a subscription reading-room. By the new catalogue it appears that there are excellent editions of the classics, several works of the fathers, a host of obscure theological writings, a thin sprinkling of publications of last century, and few or no modern publications.

The New Statistical Account of Scotland (1845)

The Leighton Library in Dunblane is the oldest purpose-built library in Scotland. The library has its origins in the bequest of the personal collection of 1,500 books by Robert Leighton (1611–84), a former Bishop of Dunblane. The building dates from 1687 and was funded by Leighton's sister and her son.

Leighton Library.

Access to the striking single-roomed library floor, which is lined with bookcases, is by a steep forestair. The vaulted basement provided accommodation for the librarian, several of whom were parish schoolmasters. The vesica-shaped panel on the frontage includes the coat of arms of Bishop Leighton and was originally inscribed 'Bibliotheca Leightoniana'.

The library was closed from the 1850s until 1989, when it reopened following a restoration programme. The collection now runs to 4,500 items, many of which have rarity value. The library is in the care of trustees and is staffed by volunteers.

# 33. Doune Castle

About half a mile below the bridge, on the north bank of the Teith, stands the old castle of Doune, roofless and ruinous, but still a majestic pile, with its two massive square towers, its machicolations, turrets, and high embattled walls.

Most striking of all is the fine commanding site, over which the trees lining the steep banks of Teith spread their dusky masses to the water's edge. A fine rambling-place for an idle forenoon is this old castle, with its spiral staircases, dungeons, and parapet walks.

*Black's Guide to the Trossachs* (1883)

O lang will his lady
Look o'er frae castle Doune,
Ere she see the Earl o' Murray
Come soundin' thro' the toon.

'The Bonny Earl of Murray', a seventeenth-century ballad

Waverley found himself in front of the gloomy yet picturesque structure [Doune Castle] which he had admired at a distance.

Sir Walter Scott
*Waverley* (1814)

Doune Castle was originally built in the thirteenth century and was rebuilt in its present form by Robert, Duke of Albany (*c.* 1340–1420), towards the end of the fourteenth century. It is grim and massive, with 40-foot-high battlements, and is strategically located on a naturally defensive promontory between the River Teith and its tributary, the Ardoch.

Doune is considered an outstanding example of a form of castle that came into vogue in Scotland after the Wars of Independence and following the breakdown

Doune Castle.

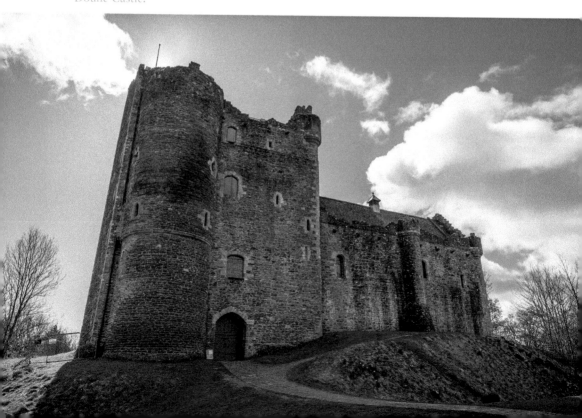

of the feudal system in Scotland. At Doune, a self-contained dwelling for the lord and his household was provided, which was separate from the accommodation for his retainers. The entrance gateway is also located within the lord's dwelling house making it completely under his control. These arrangements were in contrast with the layout of castles before the Wars of Independence in which the habitable parts of the castle were as far removed from the gateway as possible. Its origin was due to the breakdown of feudalism and the advent of mercenary warfare. Previously, the lord could depend on his tenantry, who dwelt around the castle, to defend it and all that was needed was a curtain wall to enclose his house. Under the new conditions, accommodation had to be provided for a mercenary force with his personal household separated from the garrison.

Over the centuries the castle has been a royal household, a dower house for the queens of Scotland and a hunting lodge for the Scottish monarchs. It was occupied by the Jacobites during the Rising of 1745 and as a state prison to hold Jacobite prisoners from the Rising.

By the start of the nineteenth century, after many years of neglect, Doune was a roofless ruin. In the 1880s, repair work was undertaken sponsored by George Stuart, 14th Earl of Moray (1816–95). It is now under the guardianship of Historic Environment Scotland.

Doune Castle featured in the film *Monty Python and the Holy Grail*, which accounts for the sale of coconut shells in the gift shop. In more recent years it was used as a location for the *Outlander* series.

# 34. Sheriffmuir, The Atlantic Wall

On this moor on 13 November 1715, a Jacobite army composed largely of Highlanders under the command of the Earl of Mar met a Hanoverian army consisting mainly of regular British soldiers under the Duke of Argyll, at what has become known as the Battle of Sheriffmuir. The result was indecisive, but Mar's failure to take advantage of Argyll's weakened position in the closing stages of the conflict and subsequent withdrawal from the field contributed to the failure of the Rising - known as The Fifteen - in favour of the restoration of the exiled King James VIII (the Old Chevalier).

Plaque on a cairn at Sheriffmuir

The Battle of Sheriffmuir in 1715 is commemorated by the Macrae Memorial and the Gathering Stone, on which the standard of the Scottish clans is believed to have been placed.

Sheriffmuir also bears witness to a conflict over 200 years after. During the Second World War, the Germans constructed a massive defensive wall running along the western coast of much of occupied Europe. The Allies were aware that breaching this fortress-like Atlantic Wall, which was considered by many in the German military to be impregnable, was key to plans for a successful invasion.

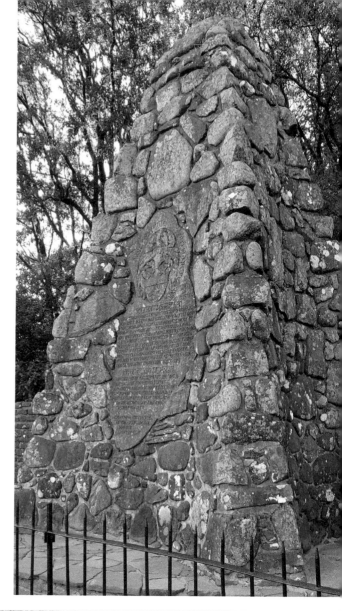

*Right*: The Macrae Memorial.

*Below*: The Gathering Stone.

The Atlantic Wall.

Fortunately, vitally important construction details of the wall had been smuggled to the British by the French Resistance. This allowed replicas of the wall to be constructed in order to assess effective means of breaching it by the armed forces that would be involved in the invasion. There are five known sites of these replica walls in the United Kingdom and the best preserved is the example that stands beside the minor road from Dunblane to Greenloaning, at Sheriffmuir.

The Sheriffmuir wall is 86 metres long, around 3 metres high and 3 metres thick along half of its length. The site also features gun emplacements, an anti-tank ditch and a bunker, which were standard features of the German coastal defences. There is a 4-metre breach in the wall and the front face is pitted by impacts from weapons that were used to test the strength of the wall.

The wall made a significant contribution to the success of the tactics that were involved in the D-Day invasion on 6 June 1944 and are a poignant reminder of the bravery of the combatants that were involved.

# 35. Deanston

Deanston Cotton Works employ about eleven hundred persons, young and old, and contain the most perfect machinery in the kingdom. The first erection took place in the year 1785, by the Messrs Buchanan of Carston. The powerful fall and supply of water in the Teith having suggested to the elder of the Buchanans, the idea of placing a cotton-spinning establishment at this spot. In the year 1793, the works at Deanston passed into the hands of a Yorkshire Quaker, a benevolent old gentleman named Flounders; and in 1808, they became the property of James Finlay and Co. from Glasgow. In 1822, the company made arrangements with the neighbouring proprietors for additional waterpower, by which they acquired a fall of twenty feet, making the whole fall thirty- three feet.

An extensive plan of enlargement and improvement was now adopted; the works were thriving, and machinery was daily becoming more and more perfect. In this plan, it was proposed to erect eight water wheels in one square building. At present four of those wheels are in operation. They are the most gigantic-looking things we ever saw. Each wheel has a power equal to eighty horses. The whole of the works are lighted with gas, and they possessed this advantage so early as 1813, before any of our towns could boast of the same brilliant light. The steadiness of the stream of the Teith renders the command of water extremely uniform, and the loss of a few hours' work per day for a week or fortnight in the driest period of summer, is all the stoppage the works ever experience. The machines used here are of a peculiar construction, in which a process formerly done by hand is now performed by mechanism, and for which Mr Smith holds a patent. The work is light and easy, but requires constant attention, and great cleanliness and order, and thus it may be said to form an excellent school for training the young to habits of attention and industry. The looms, to the number of about 300, are arranged in rows, with alleys between, in a most spacious apartment, which, when lighted with gas, has a most magnificent effect. In going over the vast establishment, it seemed to us like entering an illuminated village, and we shall not soon forget the effect of 300 gas lights in one apartment. The general order of management at the Deanston Works is very much on the principle of Arkwright – a proof of the talents of that eminent person. There is a head or superintendent to each department and in most cases, they are paid by the piece, not in weekly wages. They receive the amount of their earnings every Thursday morning (that being the market-day); and the youngest individual about the works is paid his or her wages into their own hand, which seems to give them an idea of personal consequence. The morals of the people are in general very correct; no drunkard is permitted about the establishment. Immediately adjoining the works is a handsome little village, built and founded by the company, which contains about 1200 inhabitants. The houses are neat, built in one long street parallel to the water - course, and are two stories high, with attics. They are most exemplary patterns of cleanliness, and to each house is attached a small piece of garden ground, and a range of grass plot for bleaching. The schoolroom can contain 200 children, and a teacher is paid by the company. The Sabbath-school in the village contains about 150 pupils. Thus the works at Deanston seem to possess every facility and recommendation; they have changed the aspect of the country by introducing into it habits of industry, order, and the highest mechanical genius and dexterity; they furnish employment for the people of all ages; and in all respects they are a splendid monument of British enterprise, skill, and perseverance.

<div align="right">John Forbes<br>
*The Tourist's Companion Through Stirling* (1848)</div>

The Adelphi Cotton Mill at Deanston was established in 1785 by the Buchanan family utilising the waterpower from the River Teith to spin cotton using the processes developed by Richard Arkwright (1732–92) at the outset of the Industrial Revolution. In 1793, the mill was purchased by Benjamin Flounders, a Quaker from Yorkshire. In 1808, the mills were taken over by James Finlay & Co. and expanded by James Smith (1789–1850), a nephew of the original Buchanan brothers, who was a great innovator.

Smith had 'devoted himself to the study of machinery under the celebrated Arkwright'. He invented several important pieces of machinery for spinning, including the self-winding spinning mule. At Deanston, he 'brought to the machinery the highest degree of perfection' and also made the condition and improvement of the labouring classes his principal study, and Deanston soon became remarkable not only for the splendour of its mills and water power, but also the improved habits and appearance of the labouring factory population. Smith is said to have visited the people frequently in their houses 'correcting their backsliding by serious advice or an agreeable joke, whichever best suited the person or the circumstances. As a proof of the people's reliance on his judgement and his justice, there never was a turn-out of the workpeople at Deanston during a period of upwards of thirty years'.

During Smith's lengthy time (1808–41) as manager, a lade was constructed to bring water from upstream on the Teith to power four mill wheels. The lade was one of the biggest in Scotland and the waterwheels were among the largest in Europe. At its peak the mills employed 1,100 adults and children. Cotton manufacture continued until 1965. Since then, the mill building has been used as a distillery.

The housing in Deanston was built to accommodate the mill workers in a planned industrial village, like a miniature version of New Lanark. The main street was laid out as a single row of four blocks, known as divisions, parallel to the lade with gardens to the rear and a bleaching ground next to the lade. The First Division on the north side of the road was designed for more senior employees. They date from the early nineteenth century. The cottages, closer to the river, and the school, which replaced an earlier school in the mill complex, date from the later nineteenth century.

Deanston House was built in 1820 as the residence of James Smith, the manager of the Deanston Mill. In 1880, the original modest mansion was extensively remodelled

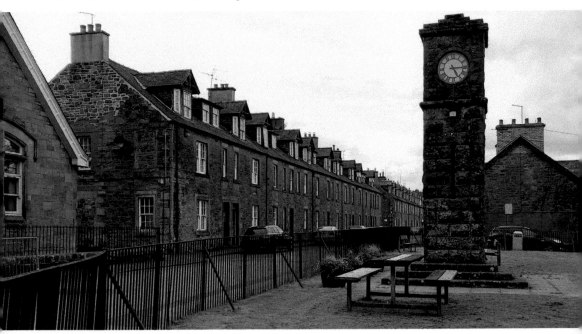

Deanston.

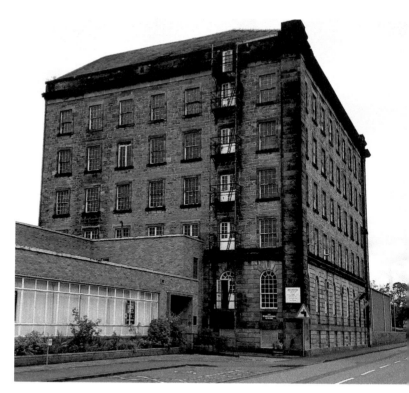

*Right*: Deanston Mill.

*Below*: Deanston House.

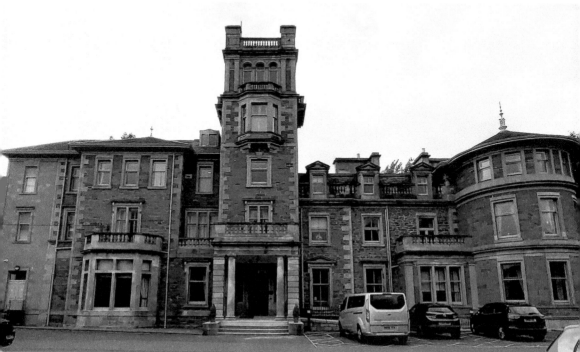

in an Italianate style by J. J. Burnet for Sir John Muir, the mill owner at the time. Since 1929, it has had a variety of uses.

The red sandstone clock tower in the village was erected on 28 December 1929 as a tribute to Lady Muir of Deanston, the wife of the Sir John Muir, the mill owner, to acknowledge 'the innumerable ways she had assisted the villagers over a period of forty years'.

# 36. Ben Gunn's Cave

I shall never forget the days at Bridge of Allan; they were one golden dream.

<div align="right">Robert Louis Stevenson<br>Letter to Henrietta Milne (23 October 1883)</div>

Bridge of Allan developed as a popular Victorian spa town in the nineteenth century. Robert Louis Stevenson (1850–94), whose health was not robust, was a regular visitor to the town with his family for the restorative properties of the area.

One of Stevenson's favourite activities while in the area was to wander along the Allan Water on the Darn Walk, an ancient scenic footpath along the river that

Ben Gunn's Cave.

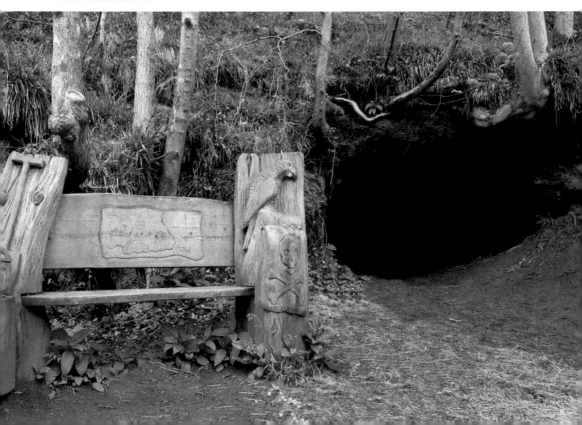

links Bridge of Allan and Dunblane. A small, dark cave on the walk is reputed to have been the inspiration for the cave inhabited by Ben Gunn in Stevenson's novel *Treasure Island*. The cave originally served as an access tunnel for the Allan Water copper mine. A bench outside the cave is carved with images relating to the book: a treasure chest, a shovel, a parrot and a map marked with an 'X'.

# 37. The Fountain of Nineveh, Fountain Road, Bridge of Allan

Major John Henderson (née Alexander, 1806–85) of Westerton House was the driving force behind improvements to the layout of Bridge of Allan that transformed the town into an attractive spa resort. His plan included wide streets, substantial stone villas and attractive pleasure grounds.

In 1853, Henderson commissioned the construction of the Fountain of Nineveh to commemorate the important discoveries by the archaeologist Sir Austen Henry

The Fountain of Nineveh.

Layard (1817–94) at the site of the ancient Assyrian city of Nineveh. The water in the fountain was turned on to commemorate special events, such as the jubilee of Queen in 1887.

The fountain now stands rather incongruously in the centre of a roundabout on Fountain Road. It features a basin with a tall Doric column surmounted by a heron, which was added in 1895.

# 38. Logie Old Kirk

The picturesque fragments of Logie Old Kirk are nestled in a tranquil spot under the rocky crag of Dumyat.

A church at Logie is first mentioned in 1178. The present structural remains are a fragment, the gable and part of the south wall, of a reconstructed church dating from

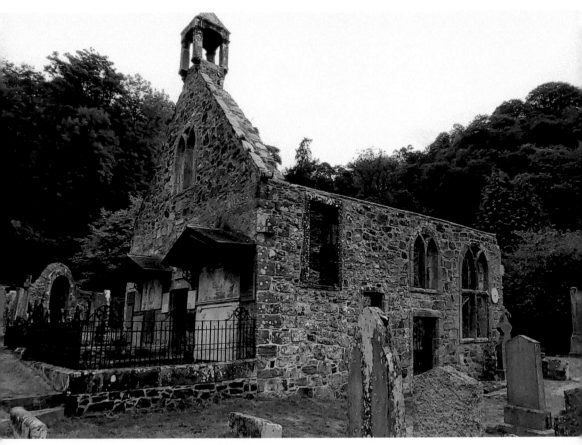

Logie Old Kirk.

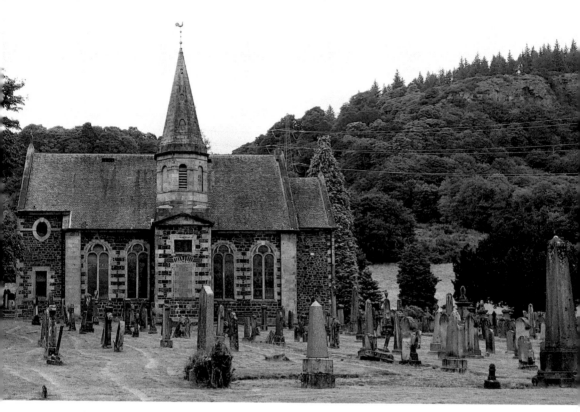

The new kirk at Logie.

1684, the date inscribed on a sundial on the building. A stone dated '1598' in the south wall indicates that the reconstruction incorporated parts of an older structure. The churchyard contains an important collection of early memorial stones, including two hogback monuments, which date from the eleventh century.

The former watch-house, adjacent to the south-west entrance of the churchyard, dates from the eighteenth century. Until 1832, there was no legal method of procuring bodies for anatomical research and this led to the ghoulish activities of the 'Resurrectionists', who at night dug up newly buried corpses and sold them to dissecting rooms. As a result of these activities the custom arose of 'watching' the grave for twenty-one days following an internment. The building is now used as an interpretive centre for visitors to the kirk.

In 1801, the church was noted as being in a ruinous condition and was abandoned in 1805, when the new church, a short distance downhill from the old kirk, was opened.

The remains of the kirk, the watch-house and the gravestones have been expertly consolidated and repaired as part of a local community project run by the Logie Old Graveyard Group.

# 39. Blair Drummond

The mansion-house of Blair Drummond was built by George Drummond, Esq., in 1715. Even then it was an elegant and spacious building, by no means unworthy of the estate or of the founder; but since that period, it has been much improved by the present proprietor, who has added an elegant and extensive wing to the original structure. It stands on the lower part of a gradually sloping ridge, which takes its rise here, and ascends westward by gentle undulations. The view from the higher portions of this ridge is not a little beautiful and extensive. The park is large and exceedingly beautiful. In the midst of it is an ornamental piece of water, abounding in wild ducks, that are here allowed to hatch and rear their young in safety, undisturbed by the gun of the sportsman. So bold have they become by the long habit of security, that the passer-by may approach very closely without their evincing the least alarm, especially in the months of October and November, when they seem to be the tamest. In the middle of this lake is an island bearing trees of various kinds, and in general

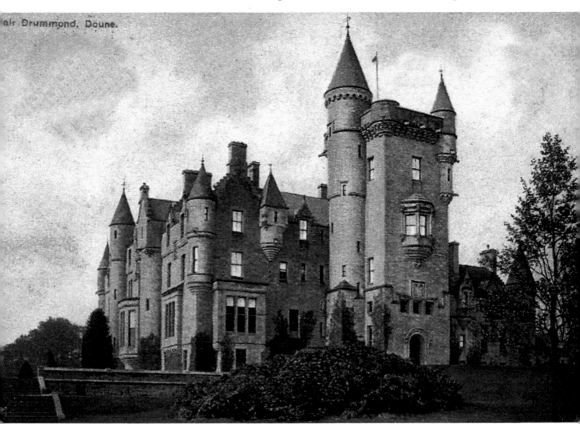

Blair Drummond.

about fifty years old. Amongst the reeds and rushes, the coots and water-rails build their nests; and here, also, the swan may be seen, in size and the majesty of its motions the Queen of the island-water.

John Bernard Burke
*A Visitation of the Seats and Arms of the Noblemen and Gentlemen of Great Britain* (1853)

In 1741, Henry Home, Lord Kames (1696–1782), married Agatha Drummond (1711–95). Home was a judge, philosopher and major figure in the Scottish Enlightenment. In 1766, Agatha inherited the ancestral estate at Blair Drummond and Home commenced a series of significant agricultural and landscape improvements on the estate. The policies at Blair Drummond, which were laid out between 1766 and 1782, reflect Home's interest in the 'natural style' of landscaping.

Home also initiated a variety of other land improvements at Blair Drummond. A large part of the estate was covered by a deep layer of unproductive moss. Earlier attempts to dig out the moss had failed due to the enormity of the task. Home had the idea of using waterpower to wash away the moss into the River Forth. Workers were hired to dig canals to float the moss to the river. However, the work involved enormous costs and Home considered abandoning the project until he arrived at a shrewd alternative scheme. It was the time of the Highland Clearances, when Higlanders were being forced to abandon their crofts to make way for the more lucrative grazing of sheep. Home offered Highlanders who were willing to locate to Blair Drummond 10 acre crofts with a rent-free tenure of seven years, provided they cleared their land of moss. As an added incentive, he provided them with a supply of meal and free use of the peat moss to heat their homes. The first of the Highlanders, or Moss Lairds as they were known, started to arrive in 1769. Within a few decades, much of the moss had been removed to reveal rich clay soil, which was agriculturally profitable.

The present mansion at Blair Drummond is a three-storey baronial-style mansion built between 1868 and 1872, replacing an earlier mansion that was first occupied in 1717. In January 1874, George Stirling Home-Drummond, the then owner of Blair Drummond, celebrated the 'heating' of the house with a grand supper and ball in the courtyard of the building, which was converted into a ballroom by the addition of a roof, a dance floor and walls decorated with drapery. Between 400 and 500 tenants of the estate attended the event. Since 1977, the house has been used as a residential home by the Camphill Trust.

The Blair Drummond Safari Park, which opened in May 1970, occupies part of the grounds of the estate to the south-east of the house.

# 40. David Stirling Memorial

The David Stirling Memorial commemorates Colonel Sir Archibald David Stirling OBE, DSO (1915–90). Stirling was a serving army office during the Second World War, and in 1941 was directly responsible for the formation of the Special Air Service

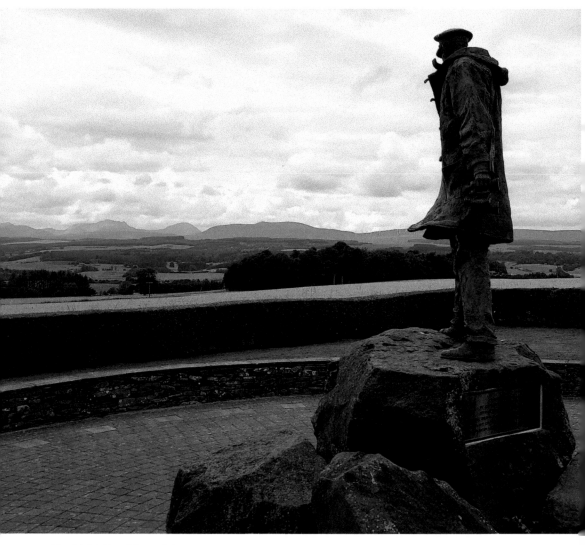

David Stirling Memorial.

Regiment, which made a significant contribution to the outcome of the war in North Africa. In 1943, Stirling was taken prisoner and, after several attempted escapes from prisoner-of-war camps, was sent to Colditz Castle where he spent the rest of the war.

The memorial, which was erected in 2002, stands on the Hill of Row on the B824 road to the south-east of Doune. The site is near Keir House, Stirling's ancestral home. The focus of the memorial is a bronze statue of David Stirling standing on a rocky plinth in the centre of a low stone wall. The memorial is also a tribute to all soldiers that have given their lives in the service of the SAS.

Even for those with minimum interest in military history, it is well worth pulling into the small car park beside the memorial to take in the outstanding views of the local countryside.

# 41. The Clachan Oak, Balfron

Balfron developed around the venerable Clachan Oak, which stands at what was the historic centre of the medieval village known as the Clachan of Balfron (or the Clachan).

The Clachan Oak, known locally as 'the Hanging Tree', is thought to be over 500 years old. It is associated in legend with Rob Roy MacGregor, who is said to have hidden in it while on the run from the Duke of Montrose, and William Wallace, which would date it to the thirteenth century.

The hollow trunk has a girth of around 16 feet and is held together by three iron rings. The metal rings originally had a more sinister purpose as a form of punishment. Offenders against the civil or ecclesiastical authorities would be forced to stand with jougs, an iron collar attached to the tree, placed round their neck as a form of public humiliation.

The tree was placed third in the Scottish Tree of the Year Award in 2014.

The Clachan Oak.

# 42. Loch Lomond

Loch Lomond is unquestionably the pride of Scottish lakes. Boasting innumerable beautiful islands of every varying form – its northern extremity narrowing until it is lost among dusky and retreating mountains, while, gradually widening as it extends to the southward, it spreads its base around the indentures and promontories of a fair and fertile land – this lake affords one of the most surprising, beautiful, and sublime spectacles in nature.

*Black's Guide to the Trossachs* (1883)

Loch Lomond. Here is one of the world's glories. The hills lie against one another fading into the blue distance; the autumn leaves, russet, red, and gold, go down to the edge of the water, and Loch Lomond lies for twenty-four miles in exquisite beauty.

H. V. Morton
*In Search of Scotland*, 1929

Loch Lomond is the largest lake in Great Britain and contains around thirty picturesque islands. The charm of the loch and the beauty of its islands have attracted appreciative visitors over the centuries.

By yon bonnie banks and by yon bonnie braes,
Where the sun shines bright on Loch Lomond,
Where me and my true love were ever wont to gae,
On the bonnie, bonnie banks o' Loch Lomond.

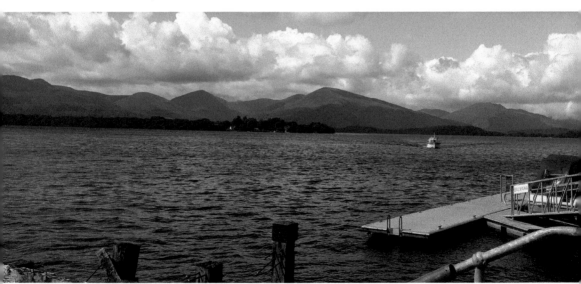

Loch Lomond.

O ye'll tak' the high road, and I'll tak' the low road,
And I'll be in Scotland a'fore ye,
But me and my true love will never meet again,
On the bonnie, bonnie banks o' Loch Lomond.

The beauty of the loch is justly celebrated in the Scottish song 'The Bonnie Banks o' Loch Lomond'. The words of the song date from the Jacobite era. Legend has it that the song tells the story of a Jacobite soldier, a native of the Loch Lomond area, who was imprisoned at Carlisle. He is visited by his sweetheart for one last meeting, before he is executed the next morning. She will then take the 'high road' back to Scotland while he takes the 'low road' of death, his soul returning underground to the place of his birth, and will be in Scotland before her.

# 43. Tom Weir Statue, Balmaha

The life-sized statue of Tom Weir (1914–2006) is a popular landmark within Weir's Rest, a small mountain garden and picnic area, on the shores of Loch Lomond in Balmaha. The statue was unveiled on 29 December 2014, Tom's 100th birthday, following a public appeal that raised the £75,000 required for the statue. The statue depicts Tom relaxing against a wall wearing his iconic bobble hat with binoculars around his neck and a rucksack at his feet.

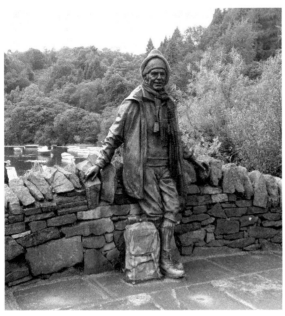

*Above left and above right*: Tom Weir statue.

Tom was a Scottish mountaineer, author and television personality. In the 1950s, he was a member of climbing expeditions to the Himalayas and Nepal. His television series, *Weir's Way*, ran from 1976 to 1987 and a whole new audience tuned in when it was repeated in a late-night slot in the mid-1990s. In the show Tom met local people and explored the Scottish countryside. He was an early activist for the protection of the environment and penned a monthly feature for *The Scots Magazine* for over fifty years.

# 44. The Trossachs

The Trossachs are not fair. A man spends months touring a country, penetrating its remote mountains, enduring heat, cold, fatigue, high teas, Sabbaths, kirks, and at the end comes suddenly on the whole thing in concentrated form, boiled down to the very essence and spread out over a small compass conveniently near to the cities of Glasgow and Edinburgh. The Trossachs are like a traveller's sample of Scottish scenery. They remind me of those small tins of biscuits which firms send out beautifully packed to indicate a range of manufactures. If you like them, you can order larger quantities. There is only one book for the Trossachs: The Lady of the Lake.

H. V. Morton
*In Search of Scotland* (1929)

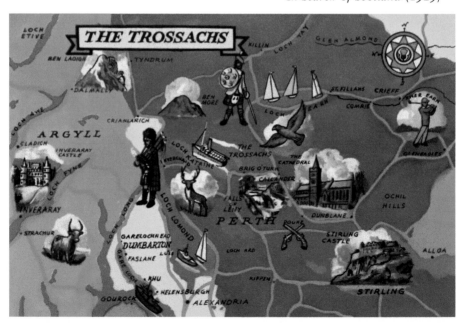

The Trossachs.

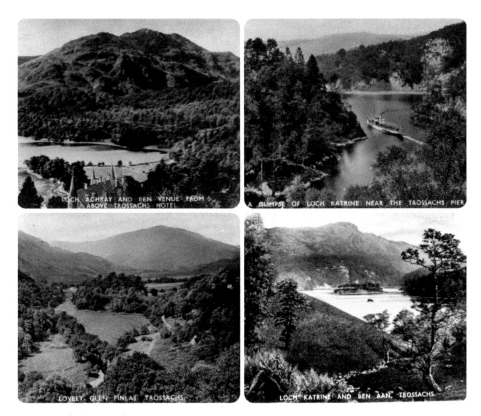

Views in the Trossachs.

The Trossachs is the area of captivating natural beauty between Lochs Achray and Katrine. The numerous scenic highlights of the Trossachs – its tangle of tree-clad mountains, glens and glittering lochs, the area's relatively easy accessibility, and its reputations as the Highlands in miniature – made it one of Scotland's first tourist destinations. Sir Walter Scott's 1810 narrative poem 'The Lady of the Lake', which is set in the Trossachs contributed to the area's popularity with Victorian visitors. (Ellen Douglas, the heroine of the poem, lives on Eilean Molach, or Ellen's Isle, on Loch Katrine.) In 2002, the importance of the area was recognised by the designation of the Loch Lomond and Trossachs National Park – Scotland's first national park.

# 45. The Trossachs Hotel

The Trossachs Hotel. A noble edifice, in Scottish Baronial architecture, fronting on Loch Achray, and 1½ miles from Loch Katrine. The Brigg of Turk and Loch Venachar are nearby, and the scenery is of exquisite beauty, while the

association of Sir Walter Scott's The Lady of the Lake hallow every hill and glade. The hotel is one of the finest in all Bonnie Scotland.

*Guide to the Best Hotels in the World* (1894)

In 1849, the Trossachs Hotel was built on the tree-lined banks of Loch Achray to meet the demand for accommodation by the growing number of tourists to the area.

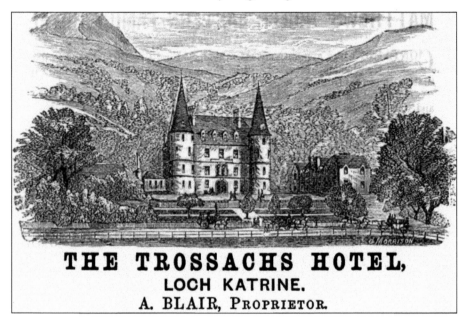

*Above and below*: The Trossachs Hotel.

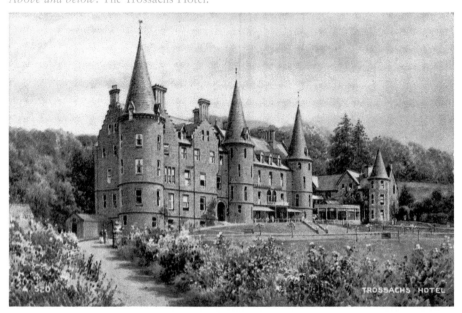

The site was the location of an earlier inn, which was popular with visitors inspired by the writings of Sir Walter Scott.

Its Scottish baronial style was a nineteenth-century revival of Scottish architectural forms taking its inspiration from the buildings of the Scottish Renaissance. One of the motivations behind its development was a revived interest in the exploration of national identity. A romantic image of Scotland had developed around the novels of Sir Walter Scott and the adoption of Scottish baronial architecture seemed to express the Scottish national identity and tradition. The hotel has been described as the Highland Camelot, due to its romantic fairy-tale-like appearance.

The original building was extended throughout the second half of the nineteenth century. The hotel fell into disrepair in the late twentieth century. In 1993, following major refurbishment and extension, it opened as the Tigh Mor Trossachs holiday apartments and its striking outline with its imposing towers continues to grace the north shore of Loch Achray.

# 46. Ben Lomond

The scene from the top of Ben Lomond comprehends on one side the Grampian mountains swelling westwards, mound after mound; on the west the Argyllshire hills; and on the south and east the great Scottish Lowland

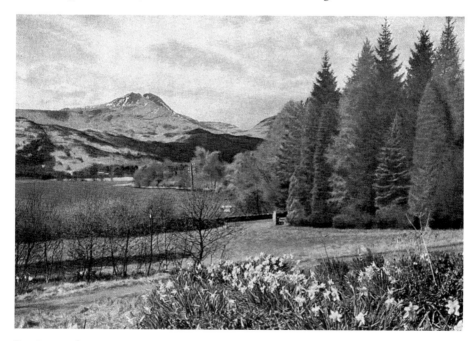

Ben Lomond.

*Up and Down Ben Lomond*, cover of the *Graphic* (September 1874).

district, with its minor mountain ranges. On a clear day the view ranges over the counties of Lanark, Renfrew, and Ayr, the Firth of Clyde, and the islands of Arran and Bute, to the south; and the counties of Stirling and the Lothians, with the windings of the Forth, and the castles of Stirling and Edinburgh to the east.

*Black's Guide to the Trossachs* (1883)

In the north, Loch Lomond penetrates the Highlands as a slender finger below a range of high mountains, including Ben Lomond (the Beacon Mountain). At 974 metres (3,196 ft) high, it is the most southerly of Scotland's 282 Munros. Ben Lomond's location, close to Scotland's Central Belt, and its relatively easy ascent from Rowandrennan have made hikes to its craggy summit popular with walkers and it can be quite busy on a fine day. A climb to the summit is rewarded by stunning views.

Since 1995, Ben Lomond has been a memorial to victims of the twentieth-century world wars.

# 47. Kincardine Bridge

Kincardine Bridge, which has the largest central swing span of any bridge in Europe, and which is free of tolls, was opened yesterday, and the distance for road traffic from the south of the Forth to the counties north of it considerable shortened. The main feature of the opening ceremony was the closing of the central span of the bridge, which connected the counties of Clackmannan and Fife with the county of Stirling. The Conveners of the three counties each turned a switch. Two of the switches were dummies, and only the engineers knew who made the connection which swung the central span into position. The ceremony, the final stage of an enterprise which began in December 1933, when Lord Bruce cut the first sod on the bridge's site, typified the way the three counties have cooperated to construct the bridge. Much of its impressiveness was lost owing to the rain which fell, and to the mist, which all but hid from view the southern shore of the Forth. Members of the general public and many invited guests were present at the ceremony, which took place at the Kincardine end of the bridge.

*Scotsman*
(30 October 1936)

The Kincardine Bridge was opened to traffic in October 1936. It was a collaboration between Fife, Stirling and Clackmannan counties, and Dunfermline and Falkirk burghs.

In the 1930s, prior to the opening of the Kincardine Bridge, motor vehicles had two options for crossing the Forth: a long queue for a ferry or the increasingly congested bridge at Stirling. The Kincardine Bridge was the first bridge crossing

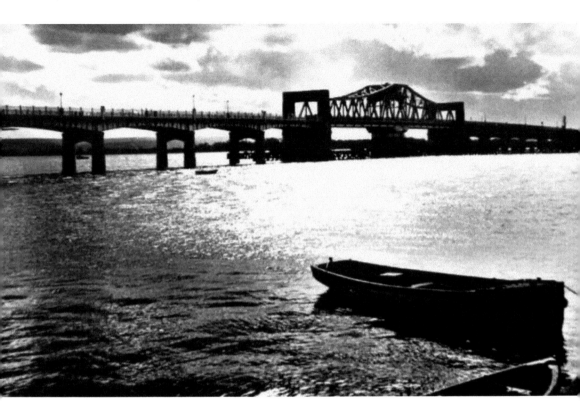

*Above and below*: Kincardine Bridge.

downstream of Stirling and was, for many, the most convenient crossing of the Forth until the opening of the Forth Road Bridge in 1964.

It was built with a central section that swivelled the 1,600-ton bridge on a pier to allow ships to navigate the Forth to the port at Alloa. At the time of its construction, the swing span of 364 feet was the longest in Europe. The swing was fixed shut in 1989, as ships no longer navigate upriver.

The new Clackmannanshire Bridge was opened in November 2008.

# 48. Castle Campbell

In the vicinity of Dollar, is the wreck of a noble castle, known as Castle Campbell, and commanding general admiration by the extraordinary boldness and beauty of its site. It crowns the summit of a wild romantic rock of an almost inaccessible character. This mount is on all sides encircled by a bosky thicket, overhanging woods and dense scrub. In the year 1493, an Act of Parliament was passed changing the name of the castle called Gloume to Castle Campbell.
*The History and Legends of Old Castles & Abbeys* (1850)

Oh, Castell Gloom! thy strength is gone
The green grass o'er thee growin'
On hill of Care thou art alone
The Sorrow round thee flowin'.
Oh, Castell Gloom! on thy fair wa's
Nae banners now are streamin'.
The houlet flits amang thy ha's
And wild birds there are screamin'.

Lady Caroline Nairne
'Castell Gloom' (1825)

Castle Campbell stands above the town of Dollar on the precipitous promontory of Gloom Hill, at the head of Dollar Glen, with the Care and Sorrow Burns forming deep-sided gorges on each side.

The original tower house dates from around 1430 and is the oldest part of the castle, which was originally known as Castle Gloom. It was likely built on the site of an earlier structure occupying the naturally defensive location. The castle was the lowland headquarters of the Campbell family, the earls of Argyll, and was renamed Castle Campbell in 1489.

The castle has witnessed important events in Scotland's history: visited by both John Knox and Mary, Queen of Scots, acting as a stronghold of the Covenanters, and besieged by Royalist forces when it was garrisoned by Cromwell's troops.

The castle was abandoned in the mid-seventeenth century. In 1805, it was sold by the Campbell family and passed through various owners until it was taken over by the National Trust for Scotland, in 1948. It is now under the guardianship of Historic Environment Scotland.

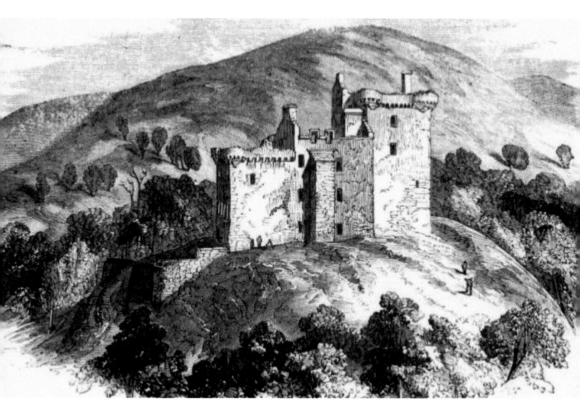

*Above and below*: Castle Campbell.

# 49. Alloa Tower

Ages on ages, still against the tide of ruthless searing Time, thy walls hath stood; Bold as thy dauntless Barons, who subdued stern foes of other days – days of thy pride. When thy roof sheltered princes. But no more life echoes through thy casements, as of yore. When gaily dazzling in the light from gems, and jetting lamps on high. And lovers' glances darting bright. Thy chambers sparkled as a sky and meteor – like beyond compare, Scotland's and Beauty's Queen was there! Stirling's far turrets, Forth's meandering stream, speak of thy bygone glories – now a dream!

<div align="right">

Alexander Bald
Alloa Tower (1825)

</div>

Alloa Tower is one of the earliest and largest surviving tower houses in Scotland. It was built for the Erskines, later the earls of Mar, and dates from the fourteenth century. Its massive walls are 11 feet thick, and it rises to 80 feet at the crenelated parapet. The massive medieval oak roof is one of the outstanding features of the tower. It was originally built to defend the ford and ferry at Alloa as part of a line of fortified structures guarding the Forth.

The Alloa Tower Building Preservation Trust carried out an award-winning restoration of the tower in the 1990s.

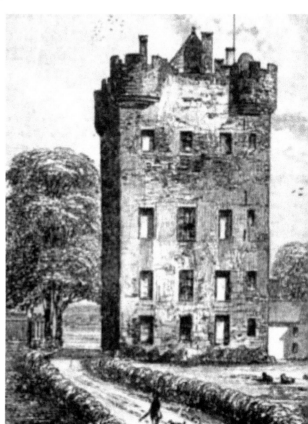

*Right and overleaf:* Alloa Tower.

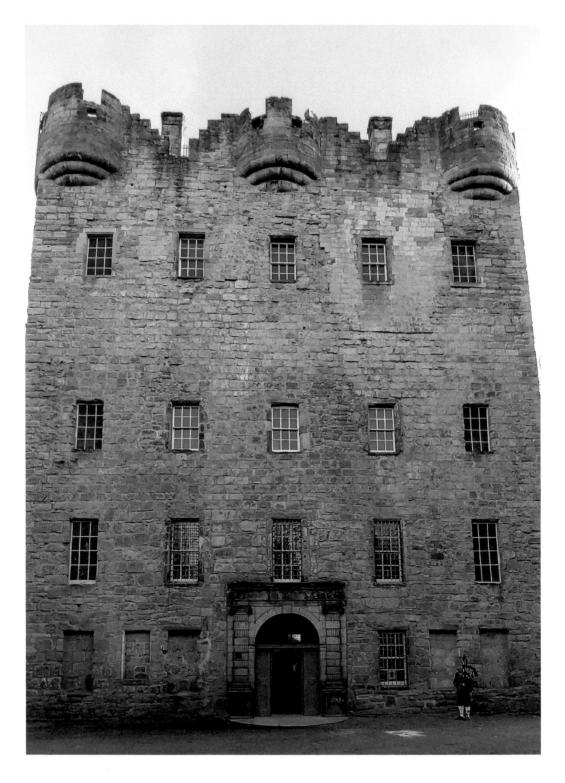

# 50. Sha Raku En, The Japanese Garden, Cowden

A unique and very attractive memento of Miss Christie's visit to Japan is the Japanese Garden which has been effectively laid out in the grounds of Cowden Castle. A Japanese garden is totally different from our conception of a garden. It neither offers fruit that may be eaten nor flowers to be plucked. A Japanese garden, more properly speaking, is a landscape which is intended to convey the idea of a favourite native scene, or even a suggestion of abstract ideas, such as peace, rest, love, old age. Miss Christie's garden is named Sha Raku En, which means a place of pleasure and delight. Situated high up on the hillside with a large reservoir as a central feature, crossed by quaint rustic bridges and having a very picturesque boathouse, the garden may very well deserve such a title.

*KinrossShire Advertiser* (6 August 1910)

The lovely Japanese Garden at Cowden also takes up a great deal of Miss Christie's time. In it she has Japanese shrubs and plants, and shrines and pagodas. It is tended lovingly by a Japanese gardener (Shinzaburo Matsuo) who carols blithely all day long in his native language.

*Courier and Advertiser* (3 December 1926)

The Japanese garden at Cowden was first established in 1908 by Isabell Robertson Christie (1861–1949) of Cowden. Miss Christie had been inspired by the striking

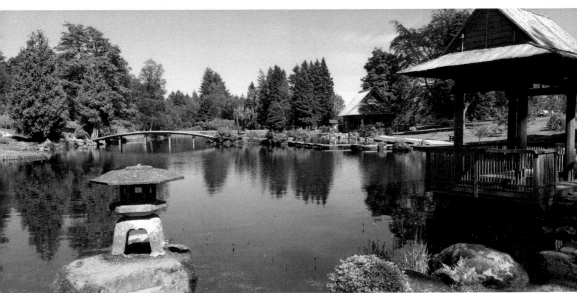

*Above and overleaf:* 'Sha Raku En'.

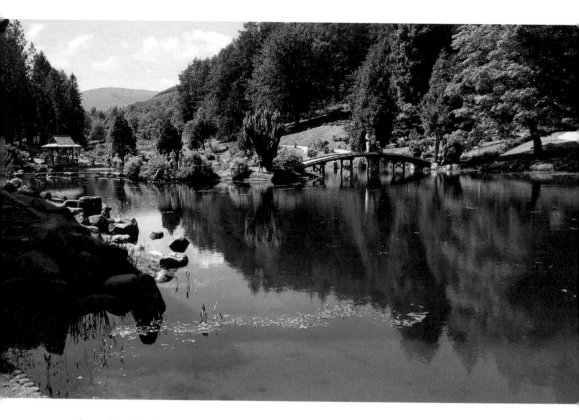

gardens she visited on a trip to Japan. Its authenticity is based on the involvement from the outset of Japanese garden designers.

In 1962, a group of youths caused extensive damage to the gardens. This was not the first time that the gardens had been targeted by vandals. In 1941, nine-year-old twin boys who had been evacuated from Clydeside were put on probation by Dunblane Juvenile Court for causing significant damage to the gardens. Since 2014, the garden has been the subject of a major restoration programme, which has reinstated its exquisite beauty and it now more than merits its reputation as the most important Japanese garden in the western world.